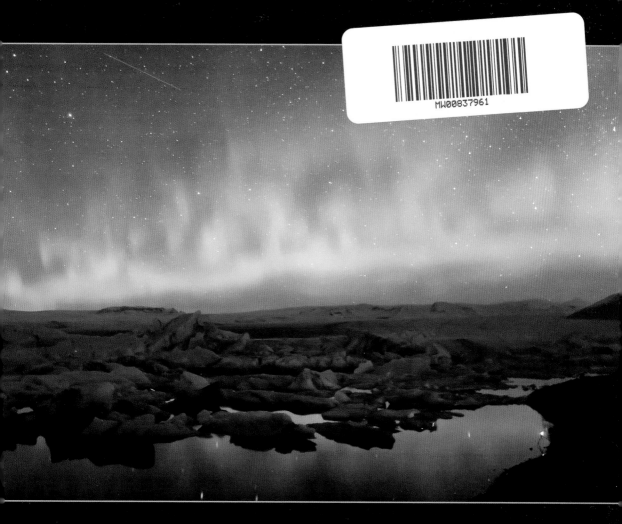

Photographing the
AURORA BOREALIS
How to Shoot the Northern Lights

Andy Long

AMHERST MEDIA, INC. ■ BUFFALO, NY

Thank You!

I'd like to thank Steve Rew, Bob Dean, and Betty Holling for their work with editing this book. You found things I missed and helped clean it up, making it a better read for everyone.

Thanks to my wonderful wife, Rhonda, for putting up with my crazy travel schedule of roaming around the globe, taking pictures, and teaching others the fine art of photography. Your support is a true blessing.

Copyright © 2017 by Andy Long.
All rights reserved.
All photographs by the author unless otherwise noted.

Published by:
Amherst Media, Inc., PO Box 538, Buffalo, NY 14213
www.AmherstMedia.com

Publisher: Craig Alesse
Senior Editor/Production Manager: Michelle Perkins
Editors: Barbara A. Lynch-Johnt, Beth Alesse
Acquisitions Editor: Harvey Goldstein
Associate Publisher: Kate Neaverth
Editorial Assistance from: Roy Bakos, Carey A. Miller, Rebecca Rudell, Jen Sexton
Business Manager: Adam Richards

ISBN-13: 978-1-68203-208-4
Library of Congress Control Number: 2016952103
Printed in The United States of America.
10 9 8 7 6 5 4 3 2 1

www.facebook.com/AmherstMediaInc
www.youtube.com/AmherstMedia
www.twitter.com/AmherstMedia

AUTHOR A BOOK WITH AMHERST MEDIA!

Are you an accomplished photographer with devoted fans? Consider authoring a book with us and share your quality images and wisdom with your fans. It's a great way to build your business and brand through a high-quality, full-color printed book sold worldwide. Our experienced team makes it easy and rewarding for each book sold—no cost to you. E-mail **submissions@amherstmedia.com** *today!*

Contents

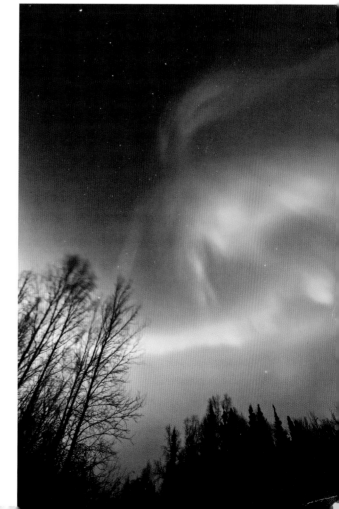

About The Author

Growing up in Florida, Andy Long started his career in sports photography and writing, but a job opportunity in Jackson, Wyoming, opened his eyes to the world of wildlife and nature photography. After several more years of sports work back in Florida, he made the move to Colorado to concentrate fully on wildlife and nature and has not looked back.

He has been leading photo workshops around the world for over twenty years and is a featured writer for several print and online photography sites. His images have appeared in more than forty different publications and books as well as in *National Geographic* and on Animal Planet television shows. His print publications include *Alaska Magazine, Outdoor Photographer, Birder's World, Outdoor Life, View* (Germany), *Colorado Outdoors,* Audubon field guides, *Texas Parks & Wildlife, Nature Photographer, Outdoor Photographer,* and *Montana Outdoors.* He was a winner in the Audubon "Share the View" contest (aurora images), Audubon Top 100, and was named the national RoseWater Network Photographer of the Year.

Like many outdoor photographers, Andy drew a lot of inspiration from the work of the master, Ansel Adams. One quote from Adams has held true for quite a long time: "Sometimes I arrive just when God's ready to have someone click the shutter." With some of the opportunities provided by the northern lights, this quote comes to life.

To learn more about Andy and his company, First Light Photography, LLC, please visit www.firstlighttours.com.

About this Book

Numerous years back, while leading an Alaska brown bears workshop, I saw some books of aurora borealis images. I was hooked—and a winter trip to Alaska to photograph the incredible beauty presented on the pages of those books was soon to follow. Ever since my initial scouting trip in 2005, I have been leading workshops yearly to the far north to let others see, experience, and photograph this amazing phenomenon.

While my true love is bird photography, my favorite thing to see and photograph is the northern lights. I'm glad that my passion of teaching others about the aurora can now reach more people through this book.

I invite you to take a journey to see some beautiful shots of the aurora and learn how you can take shots like this when—not *if*—offered the chance to visit an area where the sky comes alive with color. When you want to experience this, visit my web site, sign up for a northern lights workshop, and let me take you to the best possible spots in Alaska and Iceland—and teach you personally!

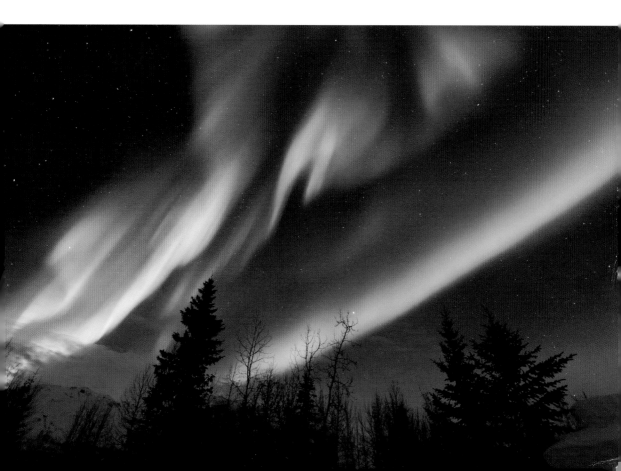

EQUIPMENT

As I am a Canon shooter, most of the images were shot with a Canon 5D Mark III or a 1Ds Mark II with multiple lenses. All of the instruction, however, is relevant for any DSLR. After all, my workshop participants have used a wide variety of camera brands and lenses to take memorable photographs.

ORGANIZATION

This book is divided into four parts:

Part 1: Understanding the Aurora—This section provides an understanding of what

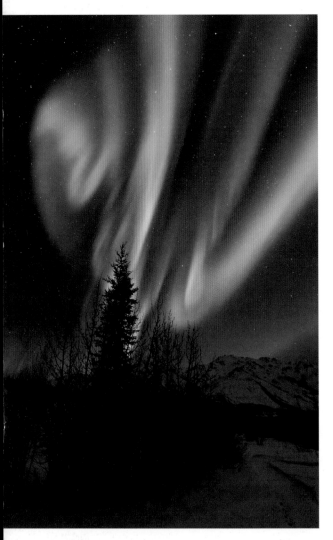

the aurora borealis is and how and why we're able to see it. The discussion will tell how the various colors come about and describe some of the shapes it takes as it dances across the sky.

Part 2: Getting You and Your Camera Ready—As you prepare to go out to photograph the northern lights, it's important to get both yourself and your camera ready. The last thing you need is to walk outside and see a great display going on and not have anything ready to take a photo. This will cover both the clothing and the equipment needed, as well as how to get it prepared for a night of shooting the aurora.

Part 3: Shooting the Aurora—This is the heart of the book, covering the why and how of capturing the shots shown throughout these pages. There's more to it than first meets the eye—with f/stops, shutter speeds, ISO, lighting techniques, timers, cable releases, and more.

Part 4: Image Processing—Some special techniques will be covered in this section, including how to put together a time-lapse film and a stacked star trail with some northern lights in it. There are also tips on what to do in post-processing to clean up aurora shots to make some beautiful prints and what to do to get them ready for posting on the web.

Understanding the Aurora

"No pencil can draw it, no colors can paint it,
and no words can describe it in all its magnificence."
—*Julius von Payer, Austrian explorer*

Legends of the Aurora

Aurora was the Roman goddess of dawn. The word "boreas" is Greek for "wind." That makes the aurora borealis the "dawn wind"—a wind that can be seen like no other on earth. The aurora has fascinated man for centuries.

Seeing the aurora is on almost everyone's "must see before I die" list. Just watching the aurora borealis is a sight to behold as you stand and become mesmerized by its movement and colors. Every country in which it appears has its own folklore and myths about what it is. However, very few got it right until the late 1800s.

In China and northern Europe, some described the aurora as dragons or serpents in the sky. In countries where gods were part of the culture (Iceland, Greenland, and Scandinavia) it was seen as a burning bridge that the gods used to travel from heaven to Earth and back.

One legend from the Inuit describes the aurora this way:

Woodcut of the aurora (Fridtjof Nansen, 1893).

The sky is a huge dome of hard material arched over the flat Earth. On the outside there is light. In the dome, there are a large number of small holes, and through these holes you can see the light from the outside when it is dark. And through these holes the spirits of the dead can pass into the heavenly regions. The way to heaven leads over a narrow bridge that spans an enormous abyss. The spirits that were already in heaven light torches to guide the feet of the new arrivals.

One Canadian legend likens the aurora to the spirits of the dead, wearing multi-

Oh, it was wild and weird and wan, and ever in camp o' nights
We would watch and watch the silver dance of the mystic Northern Lights.

And soft they danced from the Polar sky and swept in primrose haze;
And swift they pranced with their silver feet, and pierced with a blinding blaze.

They danced a cotillion in the sky; they were rose and silver shod;
It was not good for the eyes of man—'Twas a sight for the eyes of God.

—From "The Ballad of the Northern Lights" by Robert Service (1908)

colored clothing and dancing in an ethereal light to entertain themselves after the sun sets.

Some believe that whistling and making other sounds at the aurora will cause it to become more active. Others use it as a way to speak to their ancestors. Still others believe that the aurora will come down and take their heads off, thus making them observe it in silence and awe.

Those who didn't see the aurora as a supernatural being often regarded it as a predictor of the weather. Snow and bitter cold were thought to follow bright auroral displays in Scandinavia; the Eskimos saw just the opposite, with the spirits bringing favorable weather.

Some Inuit described the lights as the dancing souls of favorite animals. Some believed they were "fire foxes" that lit up the sky with sparks that flew from their glistening coats. To the Swedes, they were merry dancers—"girls running around the fireplace, dragging their pants."

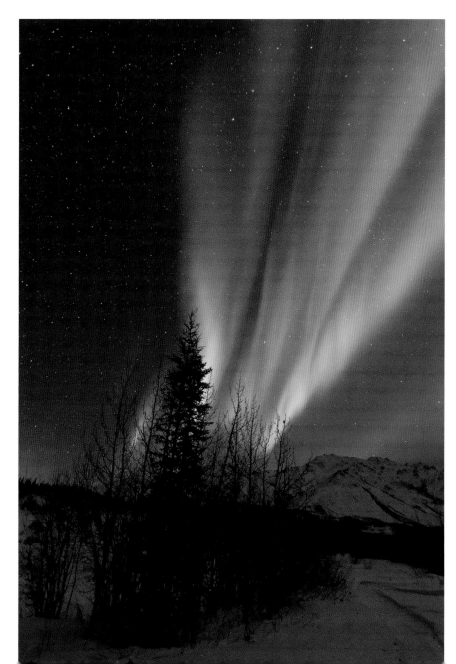

The aurora has mesmerized people for thousands of years.

History of the Aurora

For thousands of years, no one knew what the aurora borealis was or where it came from. Descriptions can be found dating to the 4th century BC, when Aristotle made the first scientific account of its glowing clouds and a light that resembled flames of burning gas. Eskimo and Scandinavian peoples have traditions of the northern lights at least as far back as 700AD.

The first detailed attempt at explanation is found in the Norwegian chronicle *The King's Mirror* from 1230AD. One theory was that the oceans were surrounded by fire and that auroras were their light reflected in the sky. Another was that reflected sunlight from below the horizon illuminated the sky, and a third explanation was they were fires from Greenland.

In the 1600s, French astronomer Pierre Gassendi is credited with being the first to name them the aurora borealis. His contemporary, Galileo Galilei, thought the aurora was caused by sunlight reflected from the atmosphere.

Swedish scientist Suno Arnelius offered his thoughts in 1708, suggesting solar rays were reflected off ice particles in the atmosphere. A strong aurora on March 6, 1716, was observed in parts of Europe and gave birth to more science. Sir Edmund Halley, of Halley's Comet fame, published the first detailed description of the aurora. He suggested that "auroral rays are due to particles, which are affected by the magnetic field; the rays parallel to Earth's magnetic field." Later in the 1700s, Anders Celsius said the lights were caused by moonlight reflected by ice and water in the air. Other

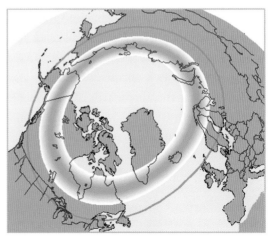

Auroral ring. *Image courtesy of Alaska Fairbanks Geophysical Institute.*

scientists believed the refraction of moonlight and the reflection of colored rays by ice crystals in the atmosphere caused the aurora.

In the 1800s, Christopher Hansteen established observing stations and arranged with sea captains to record the Earth's magnetic field, becoming the first to point out that the aurora occurs as a continuous ring around the geomagnetic pole. Sophus Tromholt organized a network of northern lights observation stations and pointed out they seemed to form a ring around the North Pole. He made the first illustration of what was later known as the auroral oval and showed occurrences correlate well with the 11-year sunspot cycle.

Around the turn of the 20th century, Norwegian physicist Kristian Birkeland placed a spherical magnet inside a vacuum chamber and shot an electron beam at it. He found the beam was guided by the magnetic field to hit the sphere near the poles. He reasoned the sun must shoot beams to-

ward Earth, where the magnetic field guides them in near the poles. His view was close to reality, except the corpuscles originate in our magnetosphere, not from the sun.

In the 1930s, Sydney Chapman and Vincent Ferraro proposed that clouds of electrically charged particles ejected from the sun fly across space and envelop the Earth. Further research showed that, as they reach the Earth's atmosphere, they go around it. Most of the flare keeps going beyond the Earth but some swirls back in and enters the atmosphere, mainly from east to west at the area of the magnetic poles.

Following the launch of Soviet and U.S. satellites, centuries of theories, observations, and speculations were put to the test. Scientists discovered that the space around the Earth is filled with high-energy particles, trapped by the magnetic field. The probes proved the existence of the solar wind, and a series of satellites mapped out the shape of the magnetosphere. Satellites in the tail of the magnetosphere found it unstable, and low altitude polar satellites measured the electrons producing the aurora. Rockets are still being sent into the aurora today, gathering even more information.

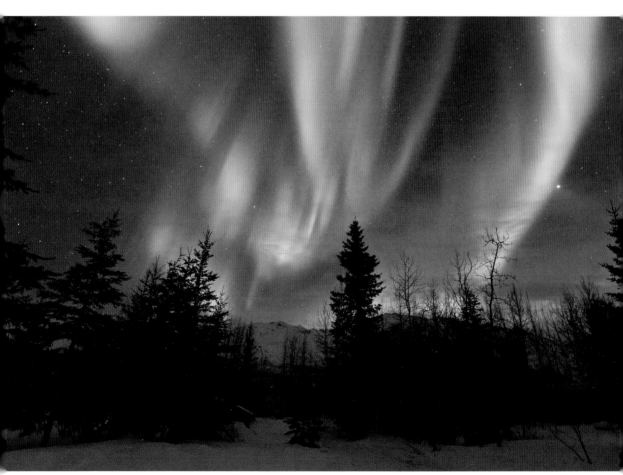

Most of the sun's flare keeps going beyond the Earth, but some swirls back and enters the atmosphere.

What Is the Aurora?

There is a lot known about the aurora. It is created by solar flares/coronal mass ejections (CMEs), which shoot out through space from the sun. As they reach the Earth's atmosphere, they go around it much like water in a river going around a rock. Most of the flare keeps going beyond Earth but some swirls back in and enters the atmosphere from east to west at the area of the magnetic poles.

The temperature above the surface of the sun is millions of degrees Celsius. At this temperature, collisions between gas molecules are frequent and quite explo-

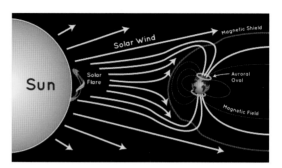

The formation of auroral bands in the northern and southern hemispheres.

sive. Electrons and protons are thrown from the sun's atmosphere by the rotation of the sun and escape through holes in its magnetic field. These CMEs release large quantities of matter and electromagnetic radiation into space. This material forms a plasma and reaches Earth in one to five days (depending on the speed of the solar wind). It takes several hours for the CME to detach itself from the sun—but when it does, it can speed through space at up to seven-million miles per hour. (By comparison, sunlight takes eight minutes to reach Earth.)

AURORAL ZONES

Most auroras occur in a band known as the auroral zone, which is at a 3 to 6 degree latitude from the geographic poles, or 10 to 20 degrees from the geomagnetic poles. This corresponds roughly with the Arctic and Antarctic

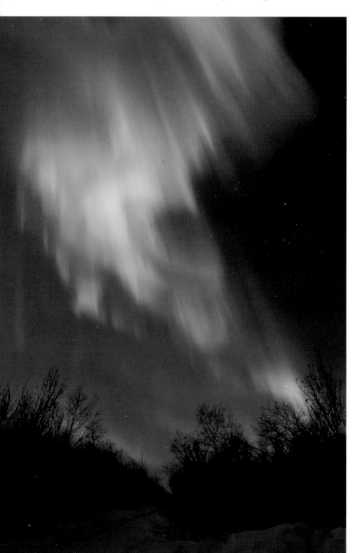

The aurora is created by solar flares/coronal mass ejections (CMEs), which shoot out through space from the sun.

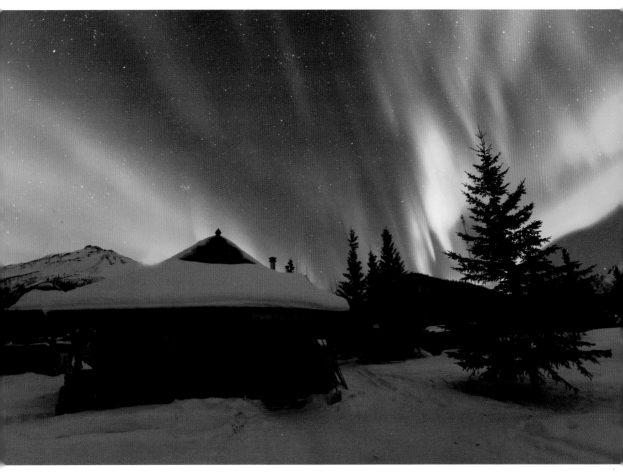

The discrete aurora has sharply defined features that vary in brightness.

Circles. The aurora enters through this area because the Earth's magnetic field is weaker near the poles.

In northern latitudes, the effect is known as the aurora borealis (or the northern lights). Auroras viewed near the magnetic pole may be high overhead; from farther away, they illuminate the northern horizon as a greenish glow or sometimes a faint red—as if the sun were rising from an unusual direction.

Its southern counterpart, the aurora australis (or the southern lights), has features that are almost identical to the aurora borealis and changes simultaneously with changes in the northern auroral zone. It is visible from high southern latitudes in Antarctica, South America, New Zealand, and Australia.

The aurora also occurs on other planets. Similar to the Earth's aurora, these auroras are visible close to the planets' magnetic poles.

DIFFUSE OR DISCRETE

The aurora is classified as either diffuse or discrete. The diffuse aurora is a featureless glow that may not even be visible to the naked eye. The discrete aurora has sharply defined features that vary in brightness from just barely visible to bright enough to read a newspaper by.

Solar Cycles _____

There are two main cycles used to determine when stronger solar activity will occur. The first is a 27-day cycle. The sun rotates on its axis, just like the Earth, and the one area of the sun that has more activity than the others faces the Earth every 27 days.

Even when this area is not facing Earth, the sun boils off enough particles from other areas to create continuous and predictable auroras over the Earth's polar regions. The solar wind also generates near-constant but lesser displays. Recently, other parts of the sun have become much more active with flares than in previous times.

The second is an 11-year cycle. It takes about this much time for the sun to go through its cycle of an increase and decrease in the number of sunspots. As it reaches the close of a cycle, new sunspots appear; a new cycle also produces more in higher latitudes. As cycles overlap, spots from a previous cycle develop even after those from the new cycle are appearing. This causes solar scientists to have a difficult time determining when one cycle ends and another begins.

Not every 11-year peak is the same. Some cycles have had 9 years between them; some have had up to 14 years. The average is 11.1 years. Durations of the peak also vary from 1 to 3 years. At the high point of the cycle, the sun produces as many as five CMEs a day; at the low point, it averages one a day. There was a period between 1645 and 1715 when sunspots were exceedingly rare. This period of solar inactivity

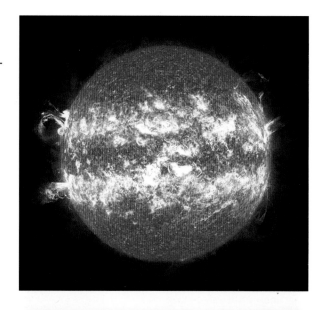

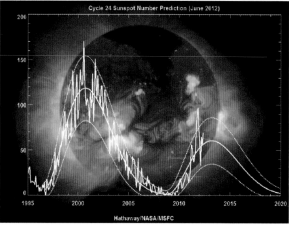

Solar cycles are used to determine when the aurora is likely to be visible.

corresponds to a climatic period called the "Little Ice Age," when normally ice-free rivers froze over and snow fields remained year-round at lower altitudes.

The year 2013 was referred to as Sun Cycle 24. While not as strong as Cycle 23, good solar activity (and thus good aurora activity) should occur through 2016 or 2017. There will then be a lull in solar flares for a few years before rising again. Locations within the auroral band will continue to have aurora activity, though.

SEASONAL VARIATIONS

In the spring and fall, the Earth is farthest north or south of the sun's equator. This is when the Earth is more likely to get the solar winds that come off the areas of high sunspot activity, making the time near the equinoxes best for aurora activity. After doing research about the best time of year and best places to photograph the aurora in Alaska, I chose a time around the spring equinox in the Brooks Range to go and photograph the aurora. This image *(top right)*, taken on March 26, 2005, was my first photo of the aurora. (I think I've gotten better!)

SOUND AND THE AURORA

Legends say the aurora emits sound. While there hasn't been extensive research, those who study the aurora do not believe there is any sound associated with it—and no recording has verified any sound coming from it.

BEST TIME

There's a time referred to as solar midnight when some of the best viewing occurs. To determine this, find out what times sunrise and sunset are. Solar noon is the time in the middle and solar midnight is 12 hours later. When the aurora is active, there is usually a strong display within 30 minutes on either side of solar midnight. A good general range of time to look for

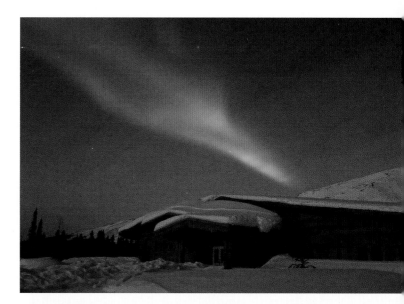

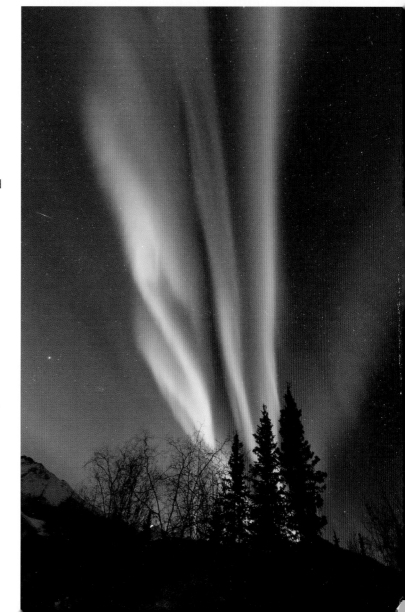

TOP—My first photo of the aurora.

BOTTOM—Multiple bands across the sky often indicate that a good bit of movement will follow.

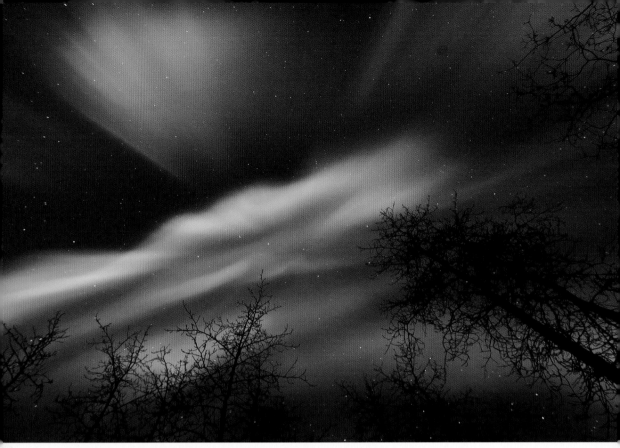

A strong auroral breakup can produce a variety of colors, shapes, and forms.

activity is between 10PM and 3AM. Don't wait until midnight to start looking for the aurora. In my experience, it has appeared as early as 8:30PM. when solar midnight was 1:30AM.

WHAT TO LOOK FOR

The auroral breakup is the most spectacular part of a display. Breakups involve a brightening of forms and a rapid change from plain to rayed to swirling and dancing across the sky. Multiple breakups can occur on a night of moderate to high activity, while a low forecast is likely to have just one or two. If multiple bands appear, watch that area; a breakup is likely. If these appear early in the evening, the breakup probably will be spectacular and continued watching may bring about several more breakups. When a big breakup occurs and then dies down, there can be a lack of activity for 30 minutes to an hour. Breakups can last close to an hour or be as short as 5 minutes—or even less.

PROXIMITY TO THE EARTH

Some people who observe the aurora think it comes down and touches the Earth. This cannot be further from the truth. The closest the aurora comes to the ground is about 45 miles—and it is generally about 60 miles above the Earth. This is the reason it has to be clear or just partly cloudy to be able to see any activity.

FORECASTING THE AURORA

With lots of research having been recorded for years, predictions provided by several sources are pretty good in giving accurate forecasts about what the aurora activity will be for the upcoming days. These are updated if a very large, fast moving, and powerful solar flare is emitted by the sun. There are web sites and phone applications that provide aurora forecasts. Some of these are listed in the "References and Resources" page in the appendix.

Several factors control the colors visible to the eye and, more importantly, to the camera. There are times when photographs reveal colors that were not seen by the eye due to the length of the exposure and the sensitivity of the ISO. For example, the appearance of red and magenta in a photo increase when a strong aurora is predicted.

One factor is which gas, oxygen or nitrogen, is mixing with the electrons in the atmosphere and how fast the electrons are moving (how much energy they have when they collide). High-energy electrons cause oxygen to emit green light; low energy electrons cause a red light. Nitrogen typically gives off a violet or pink color. Vertical blues can be seen when electrons collide with ionized nitrogen.

Another factor in color formation is altitude. The higher altitudes (over 105 miles) generate red; the middle (60 to 105 miles) generate green; the lower edge (50 to 60 miles) generate pink or violet. When the sun is "stormy," red can occur at altitudes between 55 to 60 miles and can be quite brilliant. Other colors can be found at the combinations of the different levels.

These color variances are due to the nature of the atmosphere at the altitudes and how oxygen emits light. Oxygen takes about 1 second to emit energy as green light and up to 2 minutes to emit red light at lower elevations. The atmosphere at high altitudes contains a greater percentage of atomic nitrogen and is thin, giving the atoms ample time to emit red. The pinkish color comes from a combination of red from oxygen and blue from nitrogen.

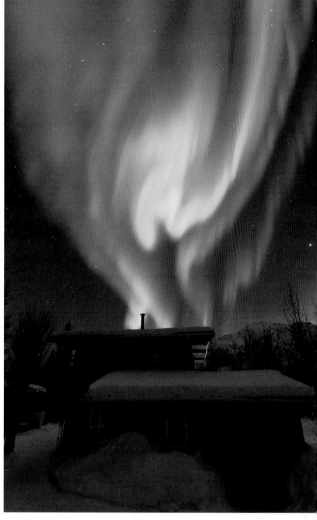

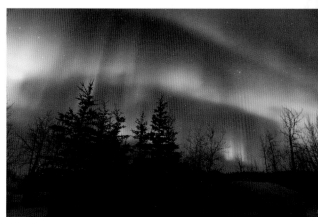

TOP—Green is the most common color when observing the northern lights.

BOTTOM—A very intense aurora gets a purple edge. The purple is from lighter gases high in the ionosphere, like hydrogen and helium.

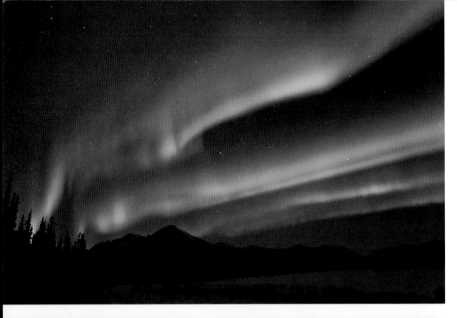

Purples can also be found at the mix of different altitudes between the layers of curtains. Quite often, these show up more in the camera than to the eye—and a little increase in the Exposure, Saturation, and Vibrance settings (explained in the image processing section) will bring these out.

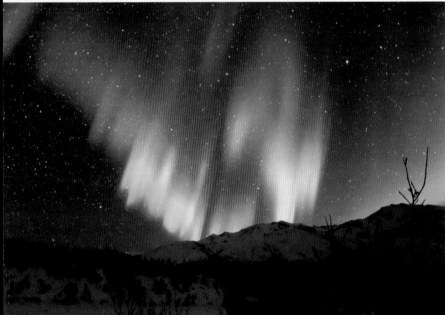

Reds are among the rarest of the aurora colors and, when visible, are a treat for everyone. Looking at the curtain, you can see they are at the higher altitudes.

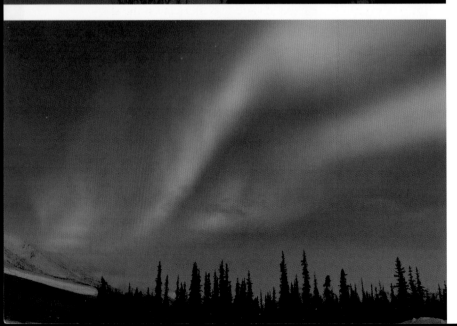

Pinks appear at the lower edge of the bands and are at the lowest altitudes, typically between 55 and 60 miles above the Earth.

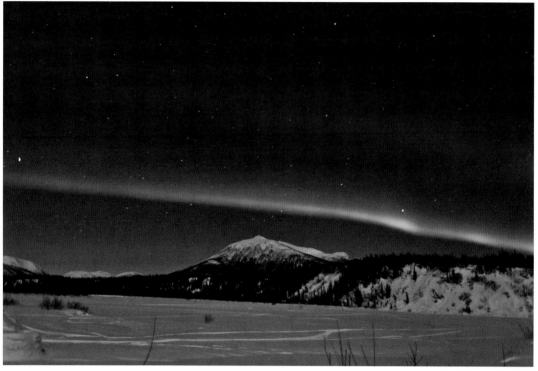

A simple homogeneous band arcing across the sky. The blue sky shows this was early in the evening.

The different shapes of the aurora are a mystery scientists are still trying to figure out. The shape depends on where in the magnetosphere the electrons originate, what causes them to gain their energy, and why they dive into the atmosphere. Even so, a variety of common shapes have been identified and given names.

HOMOGENEOUS ARC/BAND

At its least active, the aurora forms diffuse arcs with no structure hanging across the sky from east to west.

BAND WITH STRUCTURE

This is an active pattern of rapid variations. One or more bands extend east to west and rays following the Earth's magnetic field can dance across or between the bands.

CURTAIN

This is a magnificent auroral pattern where the bands and rays fill most of the sky. Waves undulate back and forth, and the light intensity varies rapidly. It is seen more when the aurora is lower on the horizon, allowing for more of a side view of the activity. This is quite a thing to observe.

RAYED ARC

When the aurora becomes more active, vertical rays form. These are actually fine pleats in the auroral curtain.

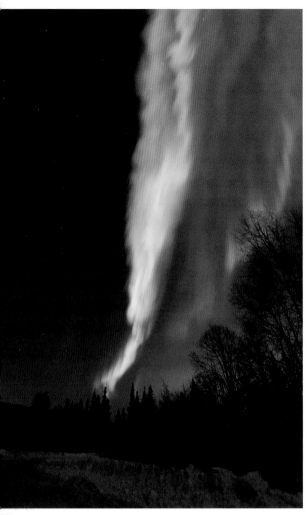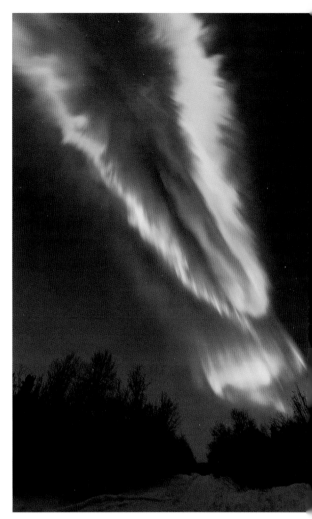

As bands get structure and get wider, it becomes more likely that splitting and movement will follow. These shots were taken a minute apart with the image on the left looking to the east and the image on the right taken to the west, showing the structured bands filling the sky from one side to the other.

RAYS

This pattern is typical of high solar activity periods. Rays are lined up along the Earth's magnetic field and move quite rapidly.

RISING VAPOR COLUMN

The auroral curtain sometimes appears to touch a mountaintop. This illusion occurs because the aurora is low on the horizon where perspective gives us the impression that it is touching the ground.

CORONA

The aurora may appear as rays shooting out in all directions from a single point in the sky. This dramatic form occurs when observed from directly beneath the swirls and folds of a curtain during periods of high solar activity.

PULSATING AURORA

When you are standing outside and it seems there is something moving but there is no color, this is a pulsating aurora. These are

When a curtain starts rippling across the sky, the pleats can be observed. The lower the band on the horizon, the more prominent the height of the curtain. A faster shutter speed can pick up more definition in the pleats than a longer exposure, which will tend to blend them together.

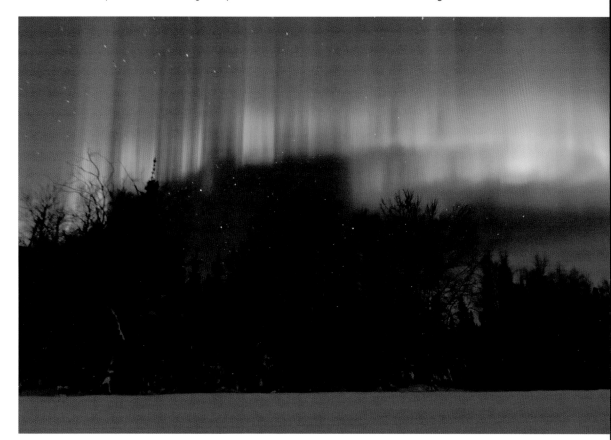

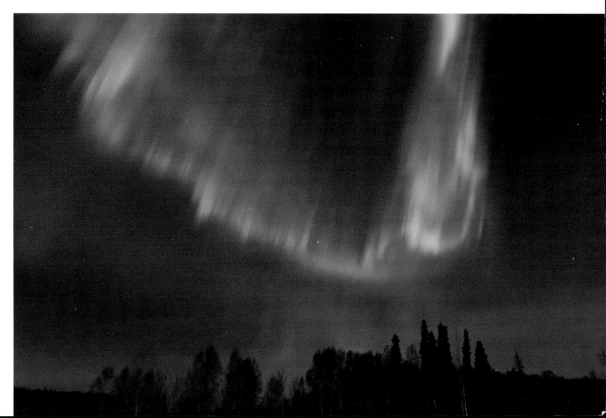

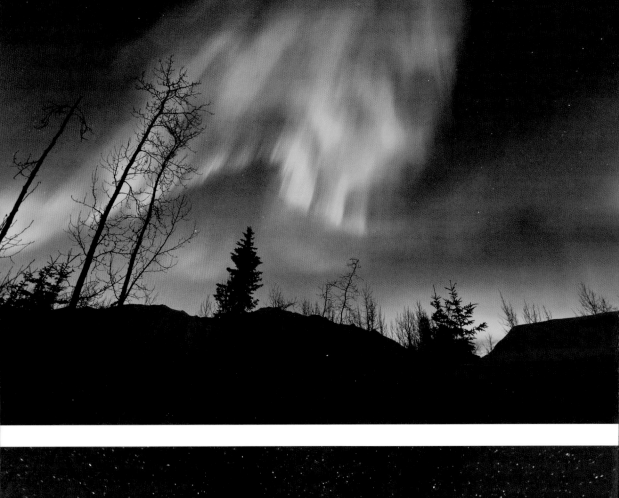
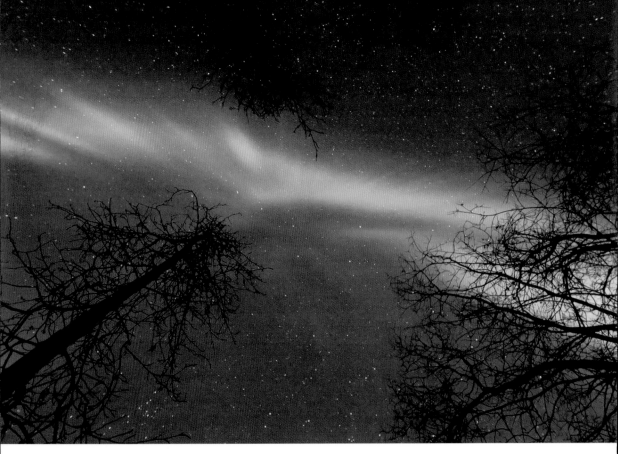

very weak and difficult to recognize, but your eyes and mind are not deceiving you.

It's said the aurora can't be seen during the day but this is only somewhat true. While colors are not visible, a pulsing sensation can occur. In the middle of the auroral band proximity, I once observed what appeared to be a heartbeat or pulsation in the sky. There was a sense it would be a good night of activity because it was seen so early—and, in fact, it was one of the best nights of aurora photography I've encountered with a group.

FIRST APPEARANCE

While this is not always the case, the aurora first appears as a homogeneous band across the sky. Once it splits into two bands, it's time to get outside for some photography. For the first-time observer, it can be good to get out at the first sign to get some photos. Usually there will not be any action or movement for a little while when it's taking this shape. It can, however, occasionally surprise you and start dancing shortly after the appearance of the first band.

FACING PAGE (TOP)—With a rayed arc, the pleats in the curtain are more apparent. The greater movement and mass indicates a very active auroral display. If I had been situated directly below this display, it would have appeared as a corona.

FACING PAGE (BOTTOM) AND BELOW—A corona will appear directly overhead. When a corona does develop, be ready to take more shots. Quite often, the bottom will drop out and color will fill the sky.

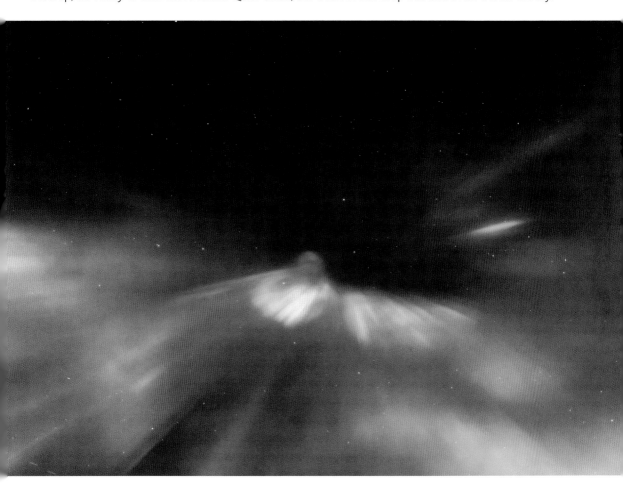

Predicting the Aurora

With the aurora fascinating so many people, both observers and scientists want to know what is going on with it at any given moment around the Earth. Currently, there are two primary outlets that provide real-time aurora forecasts: The National Oceanic and Atmospheric Association (NOAA) and the University of Alaska Geophysical Institute.

UNIVERSITY OF ALASKA GEOPHYSICAL INSTITUTE

The data provided by the University of Alaska Geophysical Institute can be found at www.gi.alaska.edu/AuroraForecast. They also have a SmartPhone app for both iPhone and Android.

On the web site, there are maps of different locations around the world with an activity level scale (1 to 10) showing how intense the aurora will be that day. It provides a forecast of the area where the aurora

can be seen and the level for up to a week. The band in this graphic shows where the aurora can be seen. The darkest green areas are for the highest probability and the white along the edges have a slight chance.

THE NATIONAL OCEANIC AND ATMOSPHERIC ASSOCIATION (NOAA)

The NOAA web site (www.swpc.noaa.gov/products/aurora-30-minute-forecast) displays a map of the northern and southern hemispheres showing where the aurora is currently active its strength. The information comes from the Polar-orbiting Operational Environmental Satellite (POES) showing the auroral oval.

The Space Weather Prediction Center and the Space Weather Prediction Testbed have introduced a new Auroral Forecast product based on the OVATION Prime model which provides a 30–40 minute forecast on the location and probability of auroral displays. This model is driven by real-time solar wind and interplanetary magnetic field information from the Advanced Composition Explorer (ACE) satellite. In addition to providing estimates of where the aurora might be visible, it also provides output in terms of energy per unit area. For the online displays, the data is converted into a relative intensity map. This has been further translated into a probability of observation. The images show both where the aurora is most likely to be observed as well as how bright it might be. The model also calculates a globally integrated total energy deposition in gigawatts with hemispheric power ranges from 5 to 150. For values

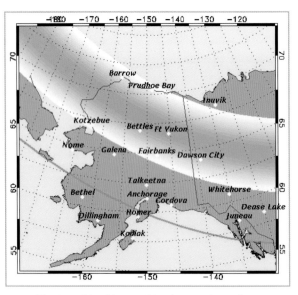

The band in this graphic shows where the aurora can be seen over Alaska.

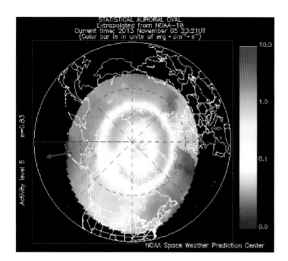

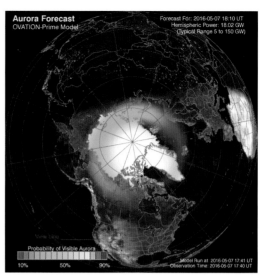

below 20, there may be little or no aurora observable. For values between 20 and 50, you may need to be near the aurora to see it. For values above 50, the aurora should be quite observable with lots of activity and motion across the sky. Once the range goes over 100, this is considered to be a very significant geomagnetic storm and the aurora may be seen for hundreds of miles.

TOP LEFT—The NOAA map showing where the aurora is currently active and how strong it is.

TOP RIGHT—Also from NOAA, an enhanced aurora graphic based on new data. This is available at www.swpc.noaa.gov/products/aurora-30-minute-forecast.

BELOW—Web sites and SmartPhone apps can help you determine the likelihood of seeing the aurora.

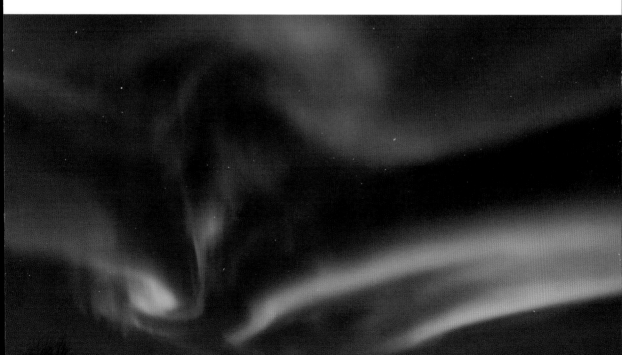

More Aurora FAQ

What are the best months to see the aurora?

Statistically, the spring (March and April) and fall (September and October) contain the most geomagnetically disturbed days, coinciding with more aurora activity. While other months have lower numbers of active sun days, the lights will probably be visible in October, November, December, January, and February, if you are situated in the right location.

The solar activity numbers shown below reflect the historic average of geomagnetically disturbed days for 1912–2007. This includes low years of the cycle, so in active years the number increases quite a bit. These are the sky conditions in Fairbanks, Alaska, one of the best spots in the United States for viewing the aurora. Looking at the combination of highest activity and clear nights shows that March is the best month to plan a visit to northern Alaska for viewing and photographing the aurora.

Can the aurora be seen during the summer—when it's not so cold?

Simply put, no. The aurora is viewed primarily around the auroral band, so summer months do not offer the dark sky needed to observe northern lights activity.

Where can the northern lights be seen?

The best place to see the aurora is in far north areas like Alaska, Canada, Greenland, Iceland, Norway, Sweden, Finland, and Siberia. They are seen in the southern hemisphere usually only in Antarctica (southern lights).

How far south can they be seen in the United States?

For a fairly strong display, it's not uncommon for the aurora to be seen in Boston, Minneapolis, and Seattle. In 2011, according to SpaceWeather.com, the aurora was seen in more than half of the U.S., with people in places as far south as Alabama, Georgia, and Arkansas seeing it. In 1989, the aurora's extreme reach showed its power as it appeared as far south as Key West, Florida, and the Yucatán Peninsula.

How long do the lights last during the night?

Anywhere from 10 minutes to all night, depending on the magnitude of the incoming

Solar Activity	Jan.	Feb.	Mar.	Apr.	Sep.	Oct.	Nov.	Dec.
Avg.	3.1	4.5	6.0	5.7	5.6	5.8	3.9	2.9
Sky	Jan.	Feb.	Mar.	Apr.	Sep.	Oct.	Nov.	Dec.
Clear	9	8	10	7	4	4	7	7
Partly Cloudy	6	6	7	8	6	5	5	6
Cloudy	16	14	14	16	20	22	18	18

The historic average of geomagnetically disturbed days for 1912–2007.

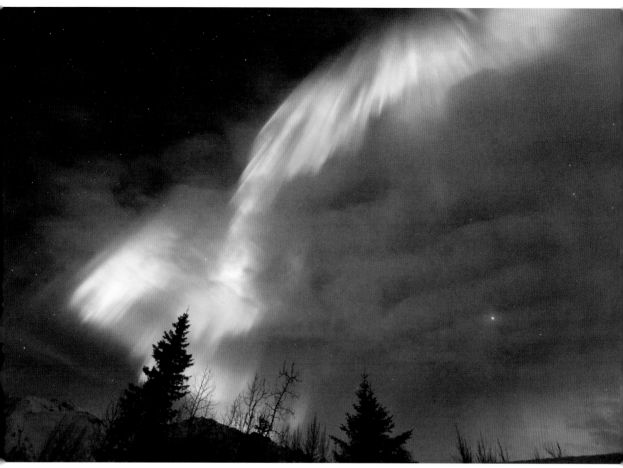

It can only be partly cloudy to see the aurora. The lowest point of the aurora is about 60 miles above the Earth; clouds are situated between 6,500 and 45,000 feet.

solar wind. Coronal holes consistently produce auroras, but big solar flares and CMEs are responsible for global aurora displays.

What is the rating scale seen on the predictions?

Every three hours, magnetic observatories around the world measure the largest magnetic change their instruments recorded during this time. The result is averaged with other observatories to produce an index that tells how disturbed the Earth's magnetic field is. This Kp index is based on a 1 to 9 scale. If the Kp is 4 or higher, it's going to produce a strong auroral display because the Earth is in the middle of a geomagnetic storm. Depending on the location, a 3 also can be quite strong—and it's not uncommon to see the aurora even when the prediction is for a 1 or 2.

Are there any harmful effects from the aurora?

There have been reports of blackouts, communication failures, and damage to satellites during extremely major solar storms, but these have happened only a few times since the early 1970s.

Can you see the aurora on cloudy nights?

It can only be partly cloudy to see the aurora. There have to be some breaks in the

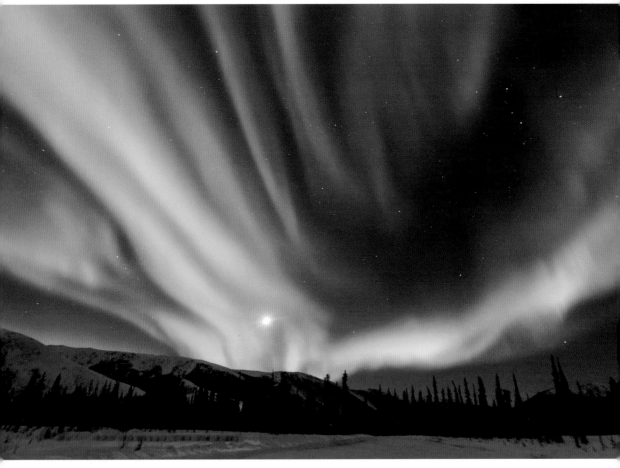

My favorite time to photograph the aurora is when the moon puts light on the foreground.

clouds, because the aurora is about 60 miles above the Earth at its lowest while clouds are situated between 6,500 and 45,000 feet. A solid cloud bank will obscure the aurora no matter how strong it is.

Can the aurora be seen when the moon is bright?

Yes. My favorite time to photograph the aurora is when the moon puts light on the foreground. When there's snow, it brings light and detail to the scene, providing a much stronger combination of foreground and aurora. We'll look at this subject in greater detail later in the book.

Can the northern lights be photographed with a point-and-shoot camera?

The answer to this is probably not. Point-and-shoot cameras are getting much better, and there are a few out there that allow access to the settings needed—but the resulting image quality may still be lacking. To photograph the aurora, a camera must offer high ISOs (800 or higher), have shutter speeds in the 10- to 30-second range, offer manual focusing of the lens, and be able to be mounted on a tripod.

Wherever the auroral band appears around the Northern Hemisphere, the aurora can be photographed. While there are chances to see and shoot it further south than the band, the intensity level has to be higher to reach these locales. Most of the areas where the band is located are not very accessible, but there are some spots where there is reasonable access.

There are eight countries where the auroral band can be regularly counted on being observed during the times of year when nights get dark during the winter months. These are: Norway, Finland, Sweden, Iceland, Greenland, Canada, Russia, and the United States.

In Russia, the band is primarily along the northern coast line and extremely difficult to reach. If you want to make the long trek, Murmansk, Siberia, and the Kola Peninsula are the spots.

In Norway, Tromsø is the preferred destination due to its location above the Arctic Circle, within the auroral oval. Other Norwegian locations include Alta, Svalbard, and Finnmark.

The area near Abisko, Sweden, is scientifically proven to be a great viewing spot. The 43-mile-long Torneträsk Lake creates a patch of sky that remains clear no matter what the surrounding weather patterns are. Other Swedish spots to go to are Kiruna and Swedish Lapland.

For Finland, Sodanklyä is the home of the Northern Lights Research Center. It's also likely to see the lights in the skies over the town of Nellim, close to Lake Inari, Finland's third largest lake. Other good spots here include Luosto, Utsjoki, Ivalo and Kakslauttanen.

Greenland is a rare destination for the average traveler, however some accessible areas in the south and east of Greenland provide good viewing opportunities. The best viewing locations are Kulusuk and Ammassalik.

For aurora-seeking Americans, the most popular overseas destination (by far) is Iceland. With easy access to Reykjavik and the entire country being within the auroral band, there are great opportunities everywhere. The most popular spots are outside of Reykjavik, Akureyri, and particularly Jökulsárlón (the Glacial Lagoon). Great landscape shooting during the days makes up for any cloudy nights.

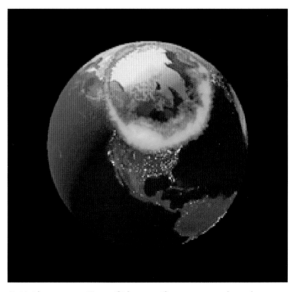

Artist's conception of the northern auroral oval expanding southward over the United States during high solar activity. *Image courtesy of NASA.*

North American Viewing

CANADA

For ease of access, North America can't be beat for finding lots of places to view and photograph the aurora borealis. By area, Canada has more aurora locations than the rest of the Northern Hemisphere put together, since the band reaches across from the Atlantic Coast to the border of Alaska.

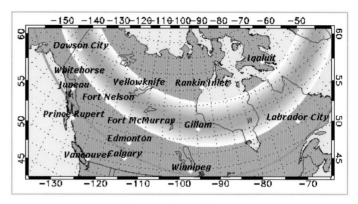

Auroral map of Canada.

Northern Canada's tundra backcountry is a prime viewing spot. Head to the town of Yellowknife (Northwest Territories) or Whitehorse (Yukon Territory) to see the swirling lights in this area. Yellowknife has become a hotbed of activity as it has promoted itself as a top aurora-viewing destination the last several years. While there is great viewing here, make sure to get well out of town to avoid light pollution; the area is flat and the light drifts a long way.

The Canadian auroral band map above shows the range for a prediction on a quiet-rated night of just a Kp1 on the scale.

ALASKA: THE LAST FRONTIER

In the United States, the only state with the band going across it is Alaska. The aurora can often be seen in Maine, Minnesota, North Dakota, and other northern states, but the intensity level has to be high. The chances to see it are low, in terms of specifically planning a trip to photograph the northern lights.

Not even all of Alaska is beneath the auroral oval, so *where* a visit is planned in the state matters. Both Anchorage and Juneau are well south of the oval—and even Fairbanks, at its high latitude, is just south of the true auroral oval.

Because of where the oval is situated over Alaska, Fairbanks is a great starting point for any northern lights trip. The further north you travel from here, the better the chances of viewing and photographing the aurora. Refer to page 24 for a view of the auroral band over the state of Alaska.

Throughout much of North America, mountain ranges are situated on a north to south axis. Several ranges in northern Alaska go east to west. Because of how the weather patterns flow, these ranges help block certain conditions and create clearer nights at different times of the year. They can also trap weather in and cause extended periods of cloudiness. More often than not, though, during winter there are quite a few cold, clear nights.

Based on the latitude of the auroral oval, as the Earth rotates, the Brooks Range in northern Alaska is right in the middle of the band during peak activity time, based on solar midnight.

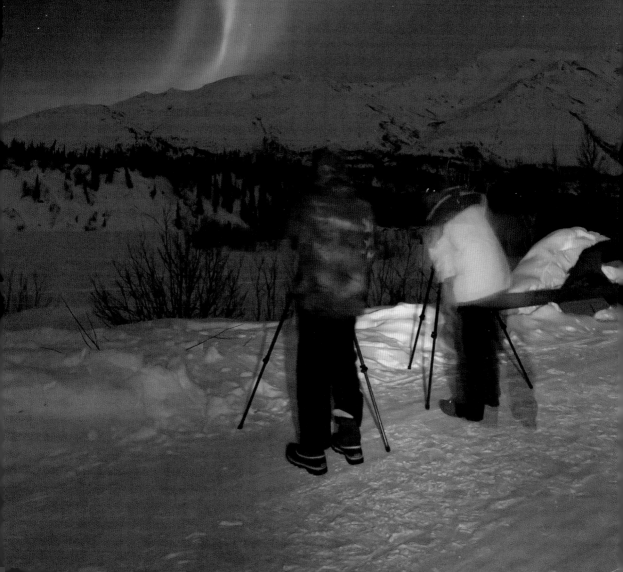

Getting You and Your Camera Ready

It's cold out there . . .

Boots

The most important thing to know about preparing to photograph the aurora is that it's going to be cold—potentially very cold.

The time of year a trip is planned, and how far north the adventure is, will determine the gear needed. In September, the temperatures will not be as cold as in February or March, and there won't be as much snow on the ground. That can make standing around for hours warmer than ground with snow pack in late winter.

A good pair of insulated or pack boots are an adequate option for being outside on a sub-zero night. Even if this is the only time you'll need the shoes, it's worth spending the extra money for appropriate shoes (and other items to keep warm) so you are not miserable standing around for several hours on the snow-covered ground.

Several companies have very good lines of insulated and pack boots (with a removable lining). Although the concept has been around for a long time, the contemporary style has a rubber sole and leather upper with a felt liner. The main idea for these boots is that the further the foot is from the ground, the warmer it will be. The thicker the soles, the greater the comfort.

When evaluating a boot's quality, the best thing to check is the lowest temperature the shoes are designed to handle. Get a pair rated for lower than the expected temperature on the trip. A shoe with a rating of –25 F or lower should be sufficient.

A good starter boot that is more than sufficient for most moderate conditions is the Sorel Caribou. Sorel makes a variety of winter boots, but the Caribou is their biggest seller (with others designed for more extreme conditions). Another maker of good winter boots is LaCrosse (www. lacrossefootwear.com). They have both pack and insulated boots. Their winter boots page sorts boots by different categories based on the needs: mild, moderate, and extreme.

If you are going to photograph the northern lights several times, a great option is "bunny boots." This is the widely used nickname for the Extreme Cold Vapor Barrier Boots used by the U.S. armed forces. These liner-free, bulbous boots retain warmth by sandwiching wool and felt insulation between layers of rubber and are worn with one pair of heavy wool socks. These boots are rated for –65 F. Bunny boots are very popular in Alaska for those who have to spend any amount of time outside during the winter.

Sorel boots.

LaCrosse boots.

Bunny boots.

TOE AND HAND WARMERS

When thinking about lower layers for cold-temperature clothing, toe and hand warmers are not typically the first thing that come to mind—but they are a very important piece in putting layers together.

There are a variety of brands on the market, but I've found the ones by Grabber to be the most reliable in the field. Other brands include Hot Hands, Heat Factory, and Little Hotties. In addition to warmers for the toes and hands, there are body warmers that can be placed between layers of clothing on the body.

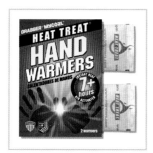

Hand warmers and toe warmers.

When using these, never place them directly against the skin; they can cause damage to both the nerves and tissue. Also, no matter how good it might feel, never use hand warmers as toe warmers. The chemical make-up is much stronger than toe warmers. Damage can occur because the skin on the toes is more sensitive and there is less circulation there (as the toes are farther away from the heart).

To use toe warmers, unpeel the protective coating to reveal an adhesive side and place the warmer on your socks. The instructions say to put them on the bottom of your toes but I have tried them both on the bottom and top and have found both work about the same. It's a good idea to take them out of the pack to expose them to air for a few minutes before putting them on. Many people say they don't seem to work at all, but they do to a certain degree—and every little bit helps when it's –20 F!

As for the hand warmers, there are several ways to make use of them. One way is to keep a pair in your coat pockets and wrap your fingers around them from time to time. The other, and recommended, way it to put them between the layers of your gloves.

TWO PAIRS OF GLOVES

When shooting the aurora, it's best to have two pairs of gloves: a liner and a heavier pair. There are two reasons. First, it's hard to work the camera with the large gloves on, and taking them off for a few minutes to change camera settings or a battery is easier with a liner. Second, it will more than likely be pretty cold outside and the two-layer system provides better insulation.

The best kind of liners are those that are skin tight, so you can easily adjust the buttons on your camera. Those that are thicker

Thin gloves as a liner make it easier to operate your camera controls.

or have grip material make it tougher to access the camera settings.

The outer gloves are a personal preference. Look for the warmest ones you can find, but be sure they are not too tight. You want air to circulate so the cold air does not get trapped between the layers and make the body feel colder. This is a tip to keep in mind for all the layers of your clothing, even boots. The outer layer needs to be snug but not tight to allow for air to move around. Trapped air only leads to feeling colder than necessary. Also, try not to have too many layers on; this will also trap the air.

MITTENS OR GLOVES?

Mittens allow the hands to be curled up easily around the hand warmers inside of them and keep the fingers closer to each other to share warmth. However, they also reduce your dexterity in using the camera, which means having to take them off to change any settings.

Shutter speeds will have to be changed throughout the night; practicing making these changes with mittens on is helpful. If not many changes are needed once the shooting starts, mittens can be used for operating the shutter or depressing the shutter button (if using the 2-second timer).

If you plan to spend a lot of time in extreme weather places, beaver mittens are another option. They cost quite a bit more than regular mittens but are well worth it. As it does for the beaver itself, the fur traps your body heat and acts like a warm blanket. Since the beaver is an aquatic animal, the mittens are also extremely waterproof.

Gloves offer greater dexterity than mittens but provide cooling surfaces around each finger, so there is a much greater

Some people like mittens or gloves with a part that folds back to expose the fingers.

Beaver mittens are a more expensive, but extremely effective, option.

Gloves offer greater dexterity but are not as warm as mittens.

area for heat loss. As noted in the previous section, be sure to select liners first and then get insulated gloves or mittens to fit over them. Gloves typically have several layers, including Thinsulate or another warming material and a waterproof outer layer.

Depending on how thick the fingers are, multiple camera functions can be used with a little bit of practice. Cable releases and shutter buttons are easily used with bulky outer gloves, as is the dial for changing the shutter speed. Accessing the small buttons for image review and other functions while wearing gloves may take a little bit of practice and patience.

THERMALS

One of the biggest recent advancements in extreme-condition clothing has come in a key area: long underwear. Long underwear was traditionally made from natural fibers, such as cotton and wool. Today, synthetic materials offer even better body temperature regulation and moisture wicking.

Now commonly referred to as thermal underwear, these garments work by trapping heat and keeping it close to the body. The most popular materials for thermals today are polypropylene and capilene.

When selecting thermal underwear, consider the following qualities:

- Ability to insulate/regulate body temperature
- Lightweight
- High-quality material
- Snug, comfortable fit
- Fast wicking

Thermals that are advertised to work great for active pursuits like skiing are not always the best for standing around photographing the northern lights. What you should *never* use as a base layer is cotton. Cotton will soak up moisture and chill the body down instead of providing warmth.

Some of the better brands to look for are Under Armour, Duofold, and North Face. Don't skimp on the cost of this item; it is the most important layer you will wear.

SOCKS

In addition to finding a really good pair of boots, socks are a key element in having warm feet. Some people like to opt for a two-layer system of socks with the first being a liner that is good at wicking away any moisture caused by the feet sweating.

The second layer should be good wool socks designated for expedition-wear or extreme cold conditions. Besides regular wool socks, Merino wool is extremely good for this. As was mentioned in the boot section, if a pair of bunny boots are being worn, only one pair of socks are recommended: a warm wool pair.

Good base layers make for a warmer and more enjoyable outing.

Thermal underwear is the most important base layer.

Wool socks are a key part of keeping your feet warm.

Outer Layers

HEAD

There's an old Inuit saying: "When your feet are cold, cover your head." Just about everyone has heard the myth that most of your body heat escapes through your head. This derives from a 1950s military experiment where subjects were exposed to extreme temperatures while wearing arctic survival suits—from the neck down. Naturally, the majority of the heat loss was from their uncovered heads. If the experiment had been performed with people wearing swim trunks, they would have lost no more than 10 percent of their body heat through their heads.

Still, hats play an important role in winter dressing. The key to keeping warm is protecting the body *evenly*. Instead of piling on layers and keeping the head bare, aim for even coverage from head to toe.

A good two-layer system works great at night when photographing the northern lights. The system will vary depending on whether you wear eyeglasses. The first layer could be a balaclava face mask that covers the cheeks and neck. If you don't wear glasses, a face mask that covers the mouth and nose can also be considered. If you do wear glasses, don't believe anything the packaging says about the face mask not fogging glasses—it's false. I have yet to see a mask that didn't fog up eyeglasses, causing condensation to freeze on the lenses.

The outer hat should cover the ears, which can become very cold if there is wind. This can be a beanie hat that pulls down over the ears, or one with ear-flaps, or even the insulated hood of an outer coat.

A balaclava covers most of the head and face.

A wool cap with ear flaps is a good outer layer and keeps your ears warm.

My preference is for a multi-material cap that does not have gaps that let the cold air through. Fleece-lined ones are very popular, as are wool hats (especially Merino wool). This can be the inner layer with the outer layer being the hood of the coat.

PANTS

The type of pants or bibs you wear is as much a personal preference as your shoes. Options can run the gamut from wool pants, to insulated ski bibs, to fleece-lined corduroy pants. I have been wearing wool pants with a pair of good thermals for years and have been fine.

If using insulated pants/bibs, make sure they're rated for –25F. Many items are

designed for skiing or snowshoeing where the wearer is constantly moving. Standing around is a lot different, so your clothing needs to be purchased with that in mind.

SHIRTS

Layers are best for the upper body, starting with the inner layer. Heavy or wool sweaters work well—but watch out for cable knit sweaters as they allow too much air through them. Wool shirts are good if the scratchiness isn't an issue. Heavy flannel shirts are also a viable option. Again, remember that cotton holds moisture and loses its insulating properties in cold weather, so this is a poor option for just about all clothing. Look for a wool mix or synthetic fibers.

COAT

Down-filled and Gore-Tex parkas work best for standing outside at night. Several people I know have tried the newer Omni-Heat jackets, but they didn't live up to the billing, so I wouldn't consider them worth the cost. Fleece does not work well for the outer layer because it's not bulky enough to trap body heat. The thicker the insulation, the better off you will be.

Whatever you purchase, make sure to talk to a salesperson and let them know you're going to an area where the temperatures could be –25F, and that you'll be standing around for long periods. They can point out items that will work best. And remember that the best jackets are not cheap.

Food and Drink

Food might not seem like an important part of the puzzle when planning to be out in the extreme cold, but it will play a role in keeping warm. In cold weather, the body temperature normally drops. Your body metabolism increases to warm the air being breathed and slightly more calories are burned to stay warm. Breathing in cold, dry air forces the body to warm that air and with each breath a bit of water is lost.

Because of this, additional fluids are needed to replace the water that gets lost. The cold also produces a decreased desire to drink, so one of the biggest needs during winter is proper hydration. At night, try to have a thermos of hot water nearby for making hot chocolate—and keep water bottles handy, both day and night.

Cold foods and fluids chill the body, so warm foods and drink are better for cold

weather. The ideal foods contain complex carbohydrates to provide the extra calories needed to help the body stay warm. Soups, chili, bread, pasta, baked potatoes, peanut butter, lean meat, and low-fat cheese are good choices.

It's also important to eat continually to replace carbohydrate stores that are being used for warming. If this energy is not replaced, your body will likely feel more chilled. Energy bars, trail mix, sandwiches, and soups are good day food. Eating not only provides fuel but also increases heat production in the body.

A word of caution in cold temperatures: you should decrease your caffeine intake, as it dries your system. Also, minimize your alcohol consumption; alcohol dilates the blood vessels and increases heat loss.

Wrapping It Up

A lot of preparation goes into getting ready for a northern lights adventure. Don't let any of this get in the way of the trip of a lifetime. Yes, it will cost a bit to get all of the clothing needed to take a trip at the best time of year (March), but the sights and memories are more than worth it.

While there are no places to rent these clothes or boots, you may be able to minimize your investment if you have friends who own some of these items and can lend them to you. You can also look online for used items. Sometimes, people buy this gear for a single adventure and then sell it after the trip. It's still a good idea to talk to a salesperson about your exact needs, but realize the items mentioned here will pretty much do it for a trip to the far north when temperatures are well below 0F.

As mentioned earlier, if a trip is planned in late September the temperatures will not be nearly as cold and the clothing can be modified. Below, I've listed the average lows/highs for Fairbanks, Alaska (a popular spot for starting an aurora trip), during the prime viewing months. Remember that predictable viewing ends in mid-April and doesn't start until September, so the temperatures for these months are skewed a bit. While the temperatures are nicer in September, there are fewer clear nights. This is true for places other than just Alaska.

Don't ruin a trip by being cold; make sure to have the right clothing.

	Jan.	Feb.	Mar.	Apr.	Sep.	Oct.	Nov.	Dec.
Average High	3	11	25	44	54	32	12	7
Average Low	−11	−7	2	21	34	16	−2	−8
Record Low	−60	−52	−41	−24	5	−27	−45	−66

Average temperatures (in F) for Fairbanks, Alaska, during prime aurora viewing months.

Camera Accessories

While preparing the body for the cold plays a key role in standing around outside in potentially sub-zero temperatures, getting your camera gear prepared is also very important. Getting everything right is critical to obtaining good images.

In this section, we'll look at the types of equipment needed, how to prepare it to go outside, and precautions you should take when going outside and back inside.

This will range from the necessary items to accessories that will make life easier when photographing the northern lights.

TRIPODS

Not many photographers put a lot of thought into their tripod, but this is one of the most important pieces of equipment for shooting the aurora. There isn't a single photographer who can keep a camera and

lens combo steady for up to 30 seconds—especially when the temperature is about –15F. Thus, a sturdy tripod is essential.

There are some inexpensive tripods out there—but, as the saying goes, you get what you pay for. These tripods tend to be clumsy, wobbly, and hard to manipulate. Generally, the leg locks are not as secure and easy to use and the load limits are not very high. Also, if a wind picks up, they tend not to be as stable as a larger tripod. Most of these come with a tripod head built onto them, which may or may not have a quick release plate for camera removal; in cold temperatures, this can be important. By choosing a low-quality tripod you are cheating yourself out of getting the best images possible.

Tripods are available in two materials: carbon fiber and aluminum. The difference between the two is cost and weight. Carbon fiber tripods cost almost twice as much as aluminum ones, but they weigh quite a bit less. For cold weather work, such as with the northern lights, the leg sections on a carbon fiber tripod do not feel as cold to the touch as those on an aluminum model. Carbon fibers have a greater weight-to-stability ratio, which is good if you do other kinds of photography with heavy lenses.

To offset the sting of touching a tripod (aluminum or carbon fiber) in cold temperatures, pipe insulation can be added

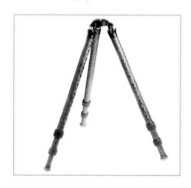

A quality tripod is critical to great aurora photos.

TRIPOD TIPS

At the end of the night, it's good to keep the tripod legs extended. Anything metal can freeze or get condensation on it. Keeping the legs extended as the tripod adapts to the temperature change can help avoid any problems the following day—such as a joint freezing up and not allowing the leg to open or close.

If the tripod is equipped with a center post, avoid raising it. When you raise it, a bit of stability is lost and you will have made a tripod into an expensive monopod with a sturdy base.

Adding pipe insulation makes the tripod more pleasant to handle in the cold.

to the top leg sections. Several companies make these pads and covers, or you can make them yourself with inexpensive pipe insulation and tape from the local hardware store. The thicker insulation also adds some cushioning that is nice when carrying the tripod and a large lens over your shoulder.

When buying a tripod, it's good to get one that is at eye level when a head and camera are attached. Stooping over to compose images can get old.

TRIPOD HEADS

A sturdy tripod with a good head that is easy to operate in the dark (with gloves on) will make composing images a lot easier.

The main options for a head are a pan-and-tilt or a ball head. There are also some pistol grip tripod heads, but I find they

don't always have the tension needed to keep the camera/lens in place when pointed up into the sky at sharp angles.

If opting for a pan-and-tilt type head, keep in mind that there will be two different adjustments to make for most shots—and potentially three. This makes setting up a composition a bit tougher and takes more time than with a good ball head. With heavy gloves on and temperatures potentially quite cold, all of this extra maneuvering can cause a bit of frustration as the night wears on. Like many other things, it's about personal preference and budget. The movements available from a pan-and-tilt head provide a very high level of control and these heads are also the most affordable solution in most cases.

For most photographers, a ball head is the best option for use on the tripod—no matter what subject is being shot. Once the camera is on a good ball head, there is pretty much just one knob to turn when moving the camera into position, making for easy recomposition. A ball head can move in a 360-degree circle, providing the easiest and best adjusting. Make sure it drops easily into a slot for switching to a vertical format.

No matter which tripod head is used, make sure the quick release plate is secure on the camera. Also, ensure the knobs for

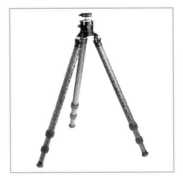

The Really Right Stuff TVC-33 tripod and BH-55 LR ball head combo I use for shooting the aurora.

positioning the direction of the shot are tight. When moving the camera around while shooting, do so by loosening the knobs on the head; turning the camera on the quick-release plate will cause the plate to become loose on the camera body.

Brands to look for include Really Right Stuff, Gitzo/Manfrotto, Giottos, and Kirk. When shooting the aurora, I use the Really Right Stuff TVC-33 tripod and BH-55 LR ball head. Both the head and tripod are very sturdy. Although this is a tall tripod that will hold a big telephoto lens, it is very lightweight, coming in at 6.15 pounds for both the tripod and head. While this combo might cost more than some people want to spend, it's important to have a good shooting base—especially if a wind picks up. This goes for all types of photography.

REMOTE RELEASES

To get the sharpest images possible when doing northern lights photography, or with any long exposure shooting, a cable release or timer is an invaluable accessory.

When working with a cable release in very cold temperatures, one problem can be expected with a wired cable release: a frozen cable that will stop working. The small wires inside can even freeze up and break. When this happens, there is a better than

 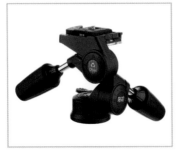

A pistol-grip tripod head (left) and a pan-and-tilt head (right).

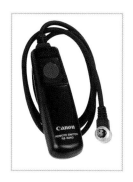
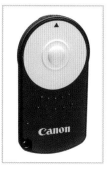
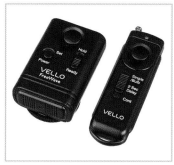

A cable release (left), a remote for the camera's native wireless shutter release (center), and an accessory wireless release set with a hot shoe–mounted sensor and remote (right).

likely chance that the device is ruined. The first sign one is going is when a button on the camera is pushed (to look at the LCD screen or another function) and doesn't operate. Unplugging the release and testing the button again will show whether the problem is with the release or the camera.

Wireless releases are also available, but most require a line of sight with the infrared eye on the front of the camera. This means you have to reach around the camera to trigger each shot. Some wireless remotes have a transmitter that slides into the flash's hot shoe and then plugs into the cable release jack; with those, the remote can be used from a variety of locations. You can even have your hands in your pockets or use the remote inside your gloves. Because the connection cable is very short and does not move once attached, there is also less likelihood of it freezing.

The best option for taking shots at night, while minimizing camera movement, is to use the 2-second timer, if that option is available on the camera. If there's only a 10-second timer, it is best to use a cable release (and hope it doesn't freeze) or to depress the shutter button gently.

BATTERIES

Cameras burn through batteries more quickly when shooting in the cold. Addi-

tionally, shooting long exposures puts a drain on the battery. More often than not, the battery will have to be changed during a night of northern lights photography.

A newer camera with a more robust battery *might* make it through the night, but it's still a good idea to have at least one extra battery readily available. When a battery goes and is replaced, it will regain a charge once warmed in a pocket for a little while. Keeping a set of hand warmers in the pocket with a switched-out battery will help revive it more quickly.

When changing batteries, having liner gloves to make the change quicker is useful. If you have to go back inside to make the switch, you may lose out on some great images. Always make sure the batteries are fully charged before beginning a night of aurora photography.

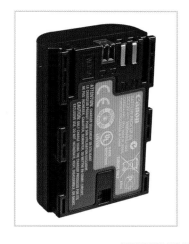

A night of aurora photography will usually require an extra battery.

FILTERS

Be sure to remove all filters from the lens being used to photograph the northern lights. Too often, filters will cause concentric rings and ruin your shots. This includes gel, plastic, and glass filters—and especially the UV filters that some camera stores suggest you leave on the lens at all times. If a polarizer happens to be on a lens and the camera is set up for proper exposures, it will cause a missed shot due to the 2-stop reduction effect it has on the exposure.

TAPE

Tape is an important accessory to add to your camera bag—and not just any tape. The best type to have is white vinyl electrical tape. Once in manual focus, the tape will be used to keep the focus ring in place, so it doesn't change while shooting during the night (more about this in part 3, on shooting the aurora).

MEMORY CARDS

In nearly fifteen years of aurora photography, I have yet to be in a situation where anyone had a problem with a memory card. NASA uses Delkin CF cards in space; with

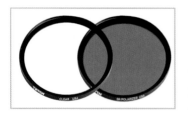

Remove any filters before you start shooting.

White electrical tape will help you lock the focus for the night.

A 16GB card (minimum) should be part of your kit.

A keychain light by Inova with red and blue lights that are good for preserving your night vision when shooting.

as cold as it is there, they would only choose cards that will hold up. SanDisk Extremes are also very reliable cards and have held up well, even though their specifications show they are recommended to just –13F.

Having extremely high capacity cards is not necessary for a night of aurora photography as not as many shots will be taken (compared to a lot of other photography genres). If the camera body being used is above 20 megapixels, it's always good to have at least a 16 GB card, so you won't be changing cards too often. If you want to try a series of time-lapse shots or a long star trails stack with the aurora, start with a fresh card that will hold a lot of RAW images. (File formats will be discussed in more detail in part 3 of this book.)

FLASHLIGHTS

When working at night, some form of flashlight or headlamp will be needed from time

to time to see the camera controls. Some people prefer a headlamp as it frees up both hands. If a head lamp is worn, make sure it's off before looking directly at someone, as it will blind them for a minute or so. If a head lamp doesn't end up working with the hats you are wearing, you can just hold it as if it were a flashlight.

I use two types of lights. One is a small key-chain type light by Inova called the Microlight that comes with different colored lights, including the two best for aurora shooting: blue and red. This colored and dim light helps maintain night vision much more than a bright white light and doesn't interfere as much with others nearby taking a photo.

I also use a small MagLite to provide light for moving from place to place.

Try to turn your light on as little as possible; after a short time, your eyes will adjust to the darkness. When you do need a light, keep the time minimal and direct it away from any nearby photographers.

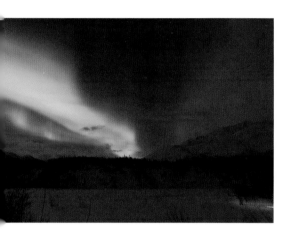

RULES FOR FLASHLIGHT USE

Here are two incidents of flashlights being turned on when others were shooting. The one on the right was a person with a headlamp turning around and illuminating part of the snow. Above, the person turned on a red light while walking out in front of people shooting.

Luckily, neither person turned toward another person and put the light right into their face—but this has happened on numerous occasions and causes the second person to lose their night vision for a couple of minutes.

When working around other people at night, be sure to ask if anyone has their shutter open and wait until no one is taking a shot. Then, try to minimize the time the light is on and do not direct it toward other photographers. Also, check to see where others are and avoid getting into anyone's shot.

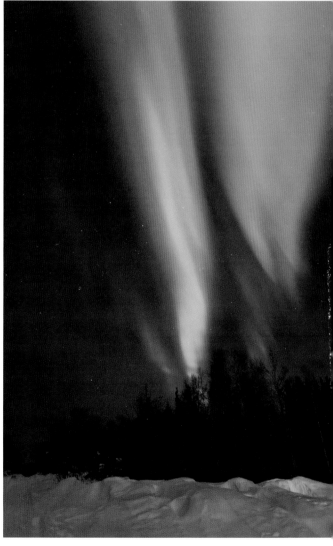

PAINTING WITH LIGHT

There are times when extra light is called for. A flashlight can be used to paint light on a foreground subject to bring out detail when there is no moonlight. For shots like the ones shown here, just a small amount of light is needed, especially if there's snow on the ground. Too much light will overexpose the snow, so just a quick on-and-off of the light source will provide enough light for the desired effect. Several attempts might need to be done with the painting to get the outcome just right, primarily because of the reflective nature of snow.

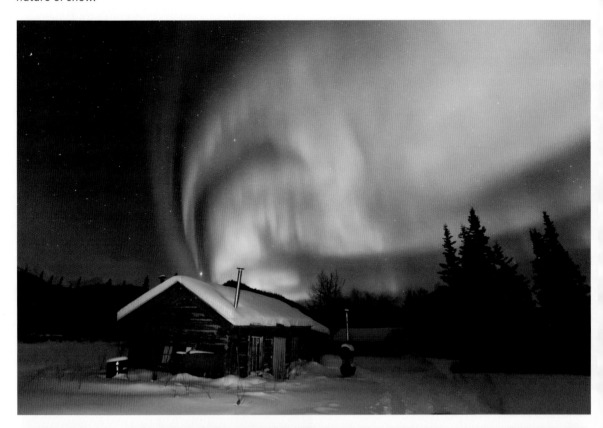

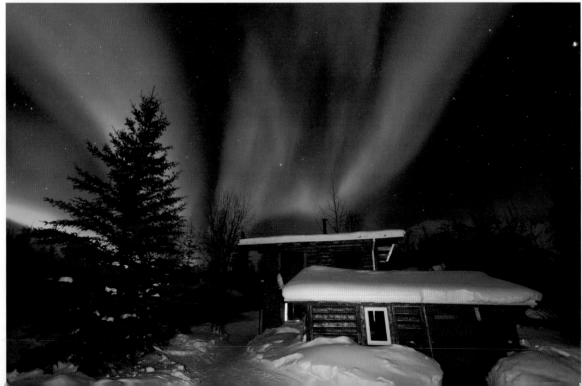

Photographing at night can push camera equipment to its limits. There may be no more demanding lens test than reproducing the colors and movement of the northern lights and stars, seen and not seen, across the camera's field of view. This is especially true when working with the aperture wide open to capture what little light is available.

In night photography, the sensor has to work extra hard to capture the few photons of light hitting it. The sensor's ability to record low levels of light while minimizing noise will largely determine the quality of the night sky images that can be captured.

Thankfully, the sensors in current DSLRs have reached amazing levels and provide results that were previously thought to be impossible. Compared to just ten years ago, today's sensor are miles ahead in technology. Imagine what it will be like in another five years! As a result, DSLRs now open up photographic possibilities that were unheard of in years past. Instead of taking images of the aurora at around 30 seconds,

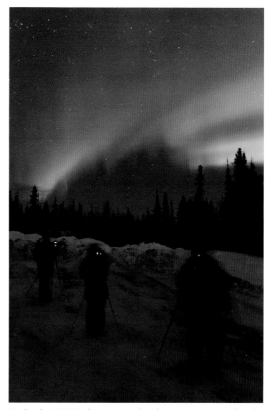

Today's DLSRs have reached amazing new levels.

they're now being taken at around 2 to 10 seconds.

Your Camera in the Cold

There is no doubt the camera will get cold. However, even in nighttime temperatures that dip into the −30F range, a camera typically will not ice over. In fact, only once have I seen a camera freeze up on someone while shooting. When they were taking a photo the shutter froze. After a little testing, we just let it warm up inside and it was fine when we tested it in the morning. This is the reason why it's best to have two camera bodies along when embarking on a potentially once-in-a-lifetime trip. You don't know when something *might* happen to one and you won't want to miss out on some great shots for the remainder of the trip.

The more time you spend outside in the cold, the slower some functions on a camera will become. At some point, it might take a second for an image review to come up.

LCD FOGGING

What happens most commonly is that the LCD screen fogs up when breathed on and the condensation on it makes image reviews tougher to see. A microfiber cloth will help clear that up.

BATTERIES

Regarding batteries and the cold, once you've established your camera settings, it's best to turn off the LCD review so it does not light up after *every* image is taken. This uses up a lot of battery power. Reviews will still need to be done from time to time, especially when the light intensity changes, but keeping these to a minimum will prolong the battery life.

LENSES

It's important not to change lenses outdoors as it's easy to get moisture or condensation inside the camera body. Sensors are very sensitive and are expensive to replace if they get moisture on them. Don't take a cold lens off inside, either; the back element will be exposed and fog up.

WHEN GOING BACK INSIDE

There are multiple ways to acclimatize a camera and keep it from icing up when going from the cold outdoors into the warmth of a building. One way is to have an extra stocking cap to put over the camera and lens outside for a little while to drop its temperature before bringing it inside and then leave the cap on the rest of the night and take it off in the morning. Some put the camera and lens in a large Ziploc bag to bring them inside; others put them in the Ziploc bag and then put it into their camera bag. A third way is to leave the camera bag outside (zipped up) while shooting. Then, put the camera, with the lens still on it, in the bag to take inside.

There are times a camera has to be taken inside for a little work with your gloves off (such as changing a battery or checking and changing some settings). The main thing when doing this is to make sure the lens cap is on before going in. If it's not, and you notice right away, take it back outside immediately and wait for the fogging to go away. It should take less than a minute. If it doesn't, a methanol-based sensor cleaner such as Eclipse will clear the lens up immediately.

MAXIMIZE YOUR OUTSIDE TIME

Try to avoid going inside too often to warm up when it is really cold outside. The more often you go back inside, the less time you'll be able to spend outside before getting uncomfortable with the cold temperature.

Stay out as long as possible, especially if the aurora is active. You don't want to miss a shot.

There are times when it is safe to go inside to take a little break. After a large breakup, the sky tends to go quiet. It usually takes a while before the activity picks up again. This is a good time to go in and get a cup of hot chocolate to warm up, but keep stepping outside to look for the aurora to start getting active again.

On one shoot, with a lot of aurora activity, one photographer complained that he didn't get many aurora shots; another chimed in he had taken well over 100 images. Which one kept going back inside to warm up?

Yes, it might be uncomfortable, but how often are you going to get a chance to see the greatest light show on Earth?

There is a wide array of digital single lens reflex (DSLR) camera bodies on the market that work just fine for photographing the aurora borealis. By far, the two most popular brands are Canon and Nikon—but every DSLR out there is capable of taking good aurora images. As a Canon shooter, my references and terminology will relate to that system, but everything mentioned will apply to other brands as well.

Today, cameras come in two formats, based on the size of the sensor: full frame and cropped. Each brand has a good selection of both full frame and crop bodies to choose from, and every year the list grows. As manufacturers make more advancements, our ability to capture aurora images improves.

As with most equipment purchases, you want to get the best product that you can afford. The following lists detail the basic pros and cons of full frame and cropped sensor bodies for photographing the aurora borealis.

FULL FRAME SENSORS: PROS AND CONS

PRO A full frame sensor has lower noise at high ISOs settings because of its larger pixels.

PRO When a lens is put on a full frame body, that is the true focal length (mm) the shooting will be done at. There is no focal-length conversion factor to consider.

PRO Generally, a full frame sensor provides a broader dynamic range, better low light performance, and a higher quality image.

CON There are times when a full frame body and a wide angle lens will cause vignetting in the corners.

CON Full frame cameras tend to be more expensive.

CROPPED FRAME SENSORS: PROS AND CONS

PRO If money is a concern, a cropped body is more reasonably priced.

PRO It's possible to use full frame lenses and APS-C lenses on a crop sensor body (but a crop sensor lens can't be used on a full frame DSLR).

PRO When using a full frame lens on a cropped sensor body, there is less vignetting.

CON On cropped sensor, all lenses function as slightly more telephoto than their true focal length. This makes it hard to attain a wide enough field of view without an ultra-wide angle lens. On a Nikon crop sensor camera with a focal length factor of 1.5, a 20mm lens provides an equivalent angle of view to a 30mm lens on a full frame camera. On a Canon crop sensor camera with a focal length factor of 1.6, that 20mm lens provides the same angle of view as a 32mm lens on a full frame camera. That's a lot of lost foreground and sky for the aurora.

The following images were taken through the years, using different camera bodies with different lenses and different sensor sizes.

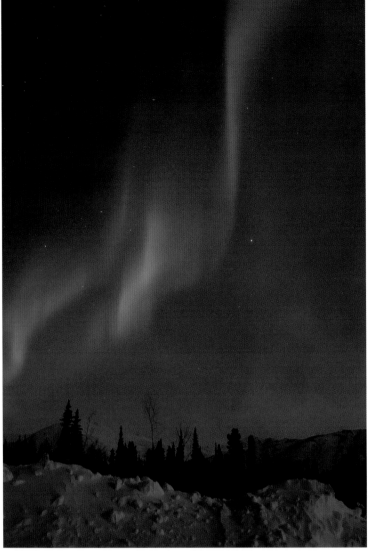

LEFT—This image was taken in March 2005 with a Canon 10D body and a 20–35mm f/3.5 lens at 20mm. The ISO was set at 400 for this 10-second exposure. The ISO and shutter speed settings were moderate due to the brightness of the moon. Notice the lack of field of view due to the 20mm lens acting as if it were a 32mm lens (due to the focal length factor of the 10D's crop sensor). This was taken on my first trip to scout and photograph the aurora while still learning proper settings.

BELOW—This image was taken with a Canon 1D Mark II body and a 16–35mm f/2.8 lens at 16mm. The ISO was set at 500 for this 30 second exposure. With the 1D Mark II having just a 1.3x crop factor, the 16mm lens translated to a 21mm lens, giving a wider field of view and a more visible sky. The larger sensor also produced less overall noise in the midtones and dark areas of the sky.

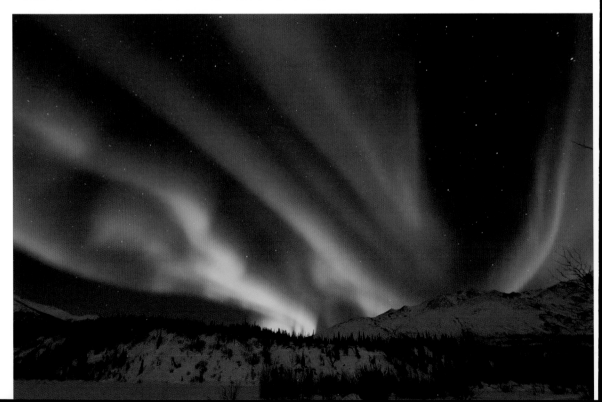

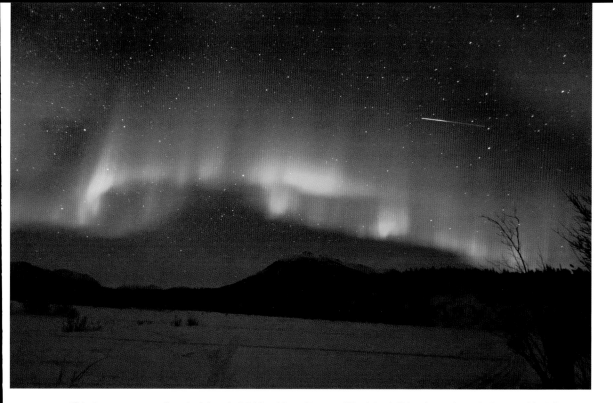

ABOVE—This image was taken in March 2010 with a Canon 1Ds Mark II body and a 16–35mm f/2.8 lens at 21mm. The ISO was set at 640 for this 30-second exposure. With a full frame sensor, the ISO and shutter speeds were pushed to see what the camera could handle. With the higher quality sensor and longer shutter speeds, more colors of the aurora began to be picked up by this camera than previous versions used. Luck plays a part in aurora photography—like in capturing this shooting star.

BELOW—This image was shot with a Canon 5D Mark III body and a 16–35mm f/2.8 lens at 16mm. The ISO was set at 2500 for this 5-second exposure. When getting a new camera body that is supposed to be able to handle high ISOs extremely well, some testing can be done. Over the period of a month in Alaska, I shot at a variety of ISOs, ranging from 1000 up to 3200 with good results.

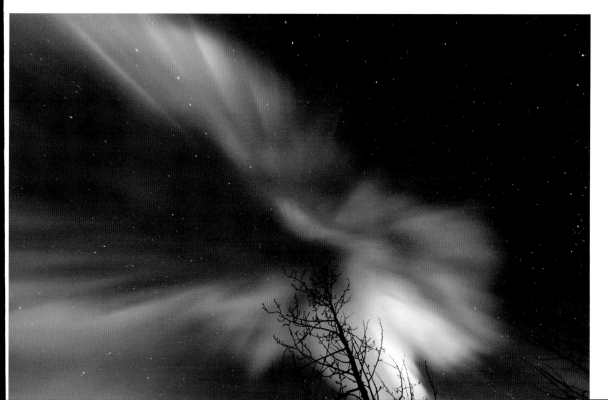

Point-and-Shoot Cameras

While it is not impossible to photograph the northern lights with a point-and-shoot (compact) camera, the images will not have the same quality as those from a DSLR. If the main intent is to see the aurora and get a photo or two, then this type of camera might be of use—but don't expect much unless you use a very high-end model.

As with DSLRs, camera manufacturers are adding more features to compact cameras and there are now some with the capacity to capture the northern lights. The biggest problem, however, is with the size of the sensor. Typical compact cameras have a sensor size of 6.17x4.55mm; more competent ones come in at a larger 7.6x5.7mm.

With demand growing and sensor prices dropping, there are now more high-end compact cameras with larger sensors. The Fujifilm X20 has an 8.8x6.6mm sensor while the Sony RX100 has an even bigger sensor at 12.8x9.6mm. The Canon G1 X boasts an 18.7x14mm sensor. These are in the high-end range of compacts—and there is now even a line of ultra high-end compacts. With even larger sensors, this group includes the Leica X2, the Fuji X100S, and the Nikon COOLPIX A, which each feature a 23.7x15.6mm sensor. There's also the Sony RX1 with a full frame sensor.

The main issue with smaller sensors is with trying to enlarge the final image. Most compact cameras lose quality at print sizes over 5x7 inches; others max out at 8x10 inches. The higher end versions can go a bit larger than this. If your aim is to just put some images on social media, the smaller compact bodies will do fine.

NEEDED FEATURES FOR COMPACT CAMERAS

- Wide-angle lens (at least 24mm)
- High ISO capability (at least ISO 800)
- Ability to change aperture to f/2.8 (or faster)
- Manual focus capability
- Ability to change shutter speed manually to between 5 and 30 seconds
- An eyepiece viewfinder
- Ability to attach the camera to a tripod
- Option to shoot RAW files

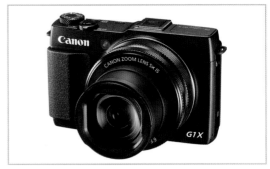

Canon G1 X.

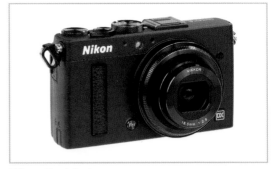

Nikon Coolpix A.

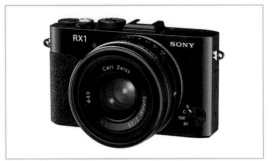

Sony RX1.

WHICH LENS SHOULD I USE?

With so many lenses available from camera manufacturers and third-party brands, choosing lenses is more complicated than selecting camera bodies. Again, though, you want to get the most for your money.

For northern lights photography, you want to be able to use a fast shutter speed—so the lens needs to be fast. The widest aperture should be around f/2.8. Nice shots can be made with an f/3.5 or f/4 lens, but a longer shutter speed will need to be used. On a newer camera that can handle high ISOs, some of the loss of speed can be compensated for by bumping up the ISO.

Another consideration is the quality of the glass. Most lens makers have two levels of glass: consumer grade and professional grade (low dispersion) glass. For Canon, their high-end lenses are in the L series; for Nikon, look for the ED series. Other companies have different designations.

Whether opting for a fast lens with regular or low dispersion glass, one requirement for an aurora lens is that it be a wide angle model, generally with a focal length of 24mm or wider. As much field of view as possible is preferable in order to get lots of sky and foreground for aurora shots.

PRIME LENS OR ZOOM LENS?

Prime lenses (fixed focal length) are typically faster and offer better optics than similarly priced zoom lenses. While there are several attractive prime lenses for full frame cameras, there are very few that offer a suitably wide field of view for cropped sensor cameras.

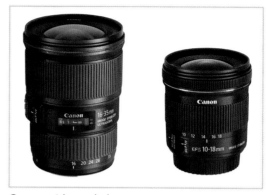

Canon wide-angle lenses.

Having experimented with a fixed focal length, ultra-wide angle 14mm, my preference for an aurora lens is a zoom that allows me to change the focal length to fit the setting. For cropped bodies, the Canon 10–22mm or Sigma 10–20mm lenses are great options and offer a super wide field of view. The Canon 16–35mm f/2.8 and Nikkor 14–24mm lenses are premium products designed for full-frame cameras, but they can also be used on cropped sensor bodies. If you are able to get an f/1.4 or f/1.8 lens, that would be even better than f/2.8 lenses; the needed shutter speeds will decrease by half with that extra stop of light from the wider aperture.

A good rule of thumb when choosing an ultra-wide angle zoom (24mm or wider) is that the zoom range should only double the focal length. Getting a lens with a wider focal length range (such as a 17–85mm) will not provide the quality optics needed to take good aurora images. In the list of lenses that appears in the next section, notice that most zooms are double the widest focal length or just a little beyond this.

Lens Options

The following is a list of good, fast, wide angles lenses to consider purchasing or renting for shooting the northern lights.

LENSES EXCLUSIVELY FOR CROPPED SENSOR CAMERAS

Some wide angle lenses are built exclusively for certain APS sensor camera bodies such as the Nikon DX series and Canon Rebel lines. Most of these lenses are not as fast as other options but have a better price point.

- Canon EF-S 10–22mm f/3.5-4.5 USM
- Nikkor AF 12–24mm f/4G IF-ED AF-S-DX
- Tokina 11–16mm f/2.8 AT-X 116 Pro
- Rokinon 16mm f/2.0 for APS-C
- Sigma 8–16mm f/4.5-5.6 DC HSM
- Sigma 10–20mm f/3.5 EX DC HSM

GOOD LENSES FOR CROPPED SENSOR CAMERAS

Fixed Focal Length (Prime)
- Canon 20mm f/2.8
- Nikkor 20mm f/2.8
- Sigma 20mm f/1.8
- Sigma 10mm f/2.8

Zoom
- Canon 10–22mm f/3.5–5.6
- Canon 15–85mm f/3.5–5.6
- Nikkor 16–85mm f/3.5–5.6
- Sigma 10–20mm f/3.5
- Tokina 11–16mm f/2.8

GOOD LENSES FOR FULL FRAME CAMERAS

Fixed Focal Length (Prime)
- Canon 14mm f/2.8L II USM
- Nikkor 14mm f/2.8 ED
- Rokinon 14mm f/2.8 IF ED
- Zeiss 15mm f/2.8 Distagon T* (has mounts for both Canon and Nikon; very expensive)
- Canon 20mm f/2.8 USM
- Canon 24mm f/1.4L II USM
- Canon 24mm f/2.8 IS USM
- Nikkor 24mm f/1.4
- Sigma 20/24mm f/1.8
- Various 28mm prime lenses (f/1.8 and faster) to suit your camera
- Fisheye lens (if wanting distortion)

Zoom
- Canon 16–35mm f/2.8 (my choice)
- Nikkor 14–24mm f/2.8.
- Nikkor 17–35mm f/2.8D ED AF
- Tokina 16–28mm f/2.8
- Various 24mm zoom lenses (f/3.5 and faster)
- Canon 24–70mm f/2.8L II
- Nikkor 24–70mm f/2.8G ED

WHY A FAST LENS?

For a wide angle lens, look for an aperture of f/2.8 or faster. Using a large/fast aperture lens in conjunction with a high ISO setting widens the shooting options. A lens of f/3.5 or f/4 is a full stop slower than f/2.8, meaning that the shutter speed will double to let in the same amount of light.

There are two benefits of using a faster lens. The first advantage is being able to re-

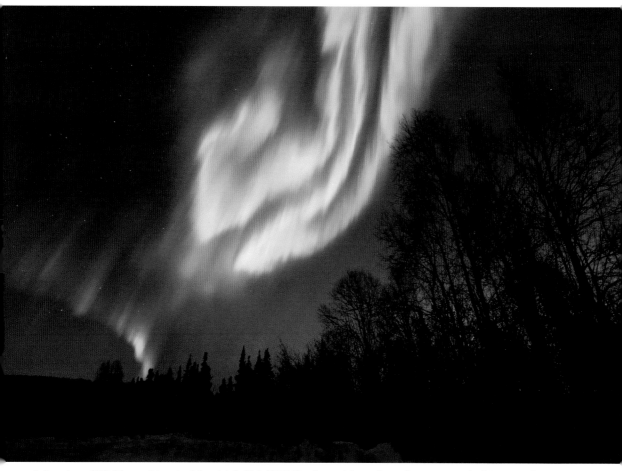

A fast lens (f/2.8) combined with a high ISO (3200) allowed for a fast shutter speed of 2 seconds, providing a lot of definition in this fast moving and constantly changing auroral display. With an exposure of 6 or more seconds, the curtain on the lower left would have been washed out and replaced by a solid band.

duce the shutter speed, allowing the camera to capture more detail in the aurora curtain and other shapes—particularly when it is dancing in different shapes across the sky. Faster shutter speeds help in bringing out this definition in your images.

The second advantage is that a fast shutter speed allows you to shoot more frames during a fast-moving display. It also increases your ability to move around to catch the action in different spots as the aurora dances across the sky from one horizon to another.

RENTING A LENS

If your shooting style does not call for a lot of wide-angle photography, renting a lens is a viable option. The savings would be well worth considering before buying a lens that might not get a lot of work beyond a single aurora trip. There are several reliable online and local rental companies listed in the resources section of the appendix.

Lens Aperture

Night photography is limited by the amount of available light. Luckily, the northern lights provide their own light. Even so, it is very common to work with the aperture of the lens wide open. This means setting the aperture to the smallest number setting available.

Some people have a hard time understanding how apertures (f/stops) relate to depth of field and shutter speed. As shown in the diagram below, f/stops refer to the opening size of the aperture diaphragm. The lowest number for this diagram is f/2.8; that is the widest aperture opening for this lens. It allows the most light to reach the camera's sensor for however long the shutter is left open. At each full stop down from this, the opening is half as large. For the same amount of light to reach the sensor, the shutter speed must be doubled.

This is part one of why a fast aperture lens is needed when shooting the aurora and why the camera is set to its widest aperture. A faster aperture = a faster shutter speed = more definition in the aurora.

But, doesn't a wide open aperture also mean a shallow depth of field, you might be thinking? Yes, it does—but also remember that the aurora is 50 or more miles up in the sky. While the foreground subject is going to be a lot closer than that (several feet or yards in most cases), focusing at infinity will be more than enough for most wide angle lenses. Most wide angle lenses have very small focusing distances before they reach infinity—in most cases, 15 feet or less. Because wide-angle lenses are designed to shoot subjects at a further distance, their focusing mechanisms are set up for that.

Since f/2.8 is the widest aperture most people have when shooting the aurora, the camera is often left there for the night. It can be dropped down a bit when there's a full moon, but the better choice is to leave it wide open and adjust the shutter speed.

If your zoom lens has a maximum aperture of f/3.5, the only option will be to use it wide open and accept whatever image quality it provides. Again, bumping up the ISO is the way to regain that lost f/stop.

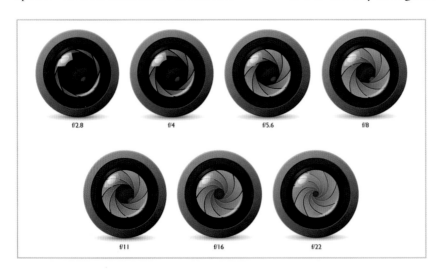

Aperture diameters and values on a wide angle lens.

Along with aperture and shutter speed, the ISO is the third part of the equation when it comes to putting everything together to obtain the proper exposure. In its most basic sense, the ISO controls how quickly the sensor reacts to light. The higher the ISO used, the more sensitive to light the sensor becomes. High ISO settings also allow the shutter speed to be reduced, which results in more defined aurora shapes. However, these higher ISO settings increase noise. This is an unavoidable problem in low-light photography, and one that will be discussed in more detail later in the book.

Here are two examples of images taken at ISO 400. The shot to the right was exposed for 60 seconds so there would be a little bit of definition in the snow, despite the lack of moonlight. Because of the long exposure the bands overlapped each other, leaving little definition. The photo below was exposed for 10 seconds due to the brightness of the moon. There is more definition in the aurora but an even higher ISO would have provided more because a faster shutter speed could have been used.

The absolute lowest ISO recommended for shooting the aurora is 400, but that's often too low; it results in very long shutter

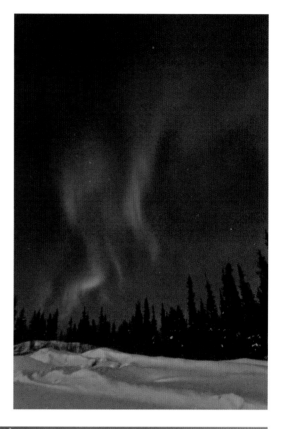

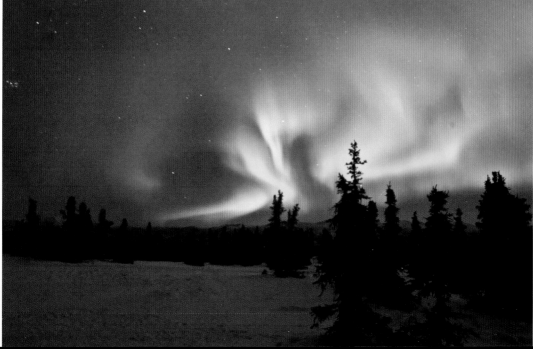

speeds—sometimes up to 60 seconds depending on the f/stop and the lighting conditions. These long shutter speeds result in very little definition in the aurora as the moving bands run together over the long duration. ISO 400 can be used when there is a moon out, putting light on both the foreground and in the sky.

CAMERA AND LENS PLAY A ROLE

How high an ISO can be chosen is partially based on the camera and lens being used.

If the lens's widest aperture is f/3.5 or f/4, bumping the ISO up to at least 800 (and preferably 1000 or 1600) is recommended in order to get fast enough shutter speeds. If the camera is just a few years old and has been recommended for being able to handle high ISOs, then starting at 1600 and going up from there is possible. Because lenses of f/3.5 and f/4 are not typically of the low dispersion variety, the quality of the image can suffer if a very high ISO is used.

If the camera is several years old or has a crop sensor, using a very high ISO setting is not encouraged. Ranges from 800 to 1600 can be used and quality images provided, especially if a lens with low dispersion glass is mounted on the camera.

It's always best to do some testing to see what your camera can handle. Before embarking on a northern lights adventure, go out at night and do some testing with the body and lens combo being used. Try multiple ISO settings such as 800, 1200, 1600, 2000, 2500, 3200 (and possibly as high as 6400) to see what the results are. Do this test on a dark night and use a variety of shutter speeds between 2 and 20 seconds. Then, look at the results on your computer,

enlarging the images to 100 percent to see what settings produce an acceptable amount of noise.

AUTO ISO

One feature on some bodies today is Auto ISO. By activating this, the camera will automatically choose the ISO based on the amount of ambient light.

While the maximum ISO range can be set, there are pluses and minuses to using this setting. If there is a certain shutter speed range you want to work with, and the ISO changes automatically, the corresponding shutter speed could be out of that range.

If a maximum range is not set, it could go to a level that is too high for the camera to handle at the corresponding shutter speed. The dynamic range could be reduced and the added noise at the higher ISO may make the image unusable. This is especially true if working with a cropped sensor body.

If this feature is preferred and a maximum range can be set, set it to 1200 for a cropped sensor and to 2500 or possibly 3200 for a full frame camera.

Some cameras will show very high ISO settings as H1 or H2, rather than as an ISO figure. Refer to the manual if it's not clear what speeds these correspond to. In some cases, these settings are enabled through a custom settings menu. Generally, there is little benefit to using these very high settings, especially when shooting RAW.

It's best to have control over the various settings on the camera, so I suggest ignoring the Auto ISO feature. However, if this is something you use a lot and are comfortable with, then go ahead and use it.

WHAT'S MY BEST ISO?

For shooting the aurora, select a high ISO setting that gives a well-exposed image on the LCD. This can be as high as ISO 3200 with quality zoom lenses and ISO 2000 for a fast prime lens. Although shooting at a lower ISO setting and post-processing it for similar results can be done, it's important to see the image clearly on the LCD while shooting to assess the composition and get excited about what's being shot. On the low end, try not to go below 800 ISO if possible. My preferred ISO is 2500.

In bright moonlight, a fully exposed image can be made at a lower ISO setting. If the aurora is bright, adjust the shutter speed down. Another consideration is how quickly the aurora is moving and how fast a shutter speed can be used.

ISO selection is also based on how much post-processing work you want to do and what the final product of the shoot is going to be. A very large print will require less visible noise than a smaller 12x16-inch print. Projection on a large HD television or through a projector also requires a cleaner image. If you're shooting for pure enjoyment, then amplified noise is not a big concern.

As illustrated over the next few pages, any ISO can be used and a good photo of the aurora can be the result. Notice, however, that higher ISOs yield more shape definition because faster shutter speeds can be used. The main thing this shows is that knowing what your equipment can handle is critical to producing a good shot.

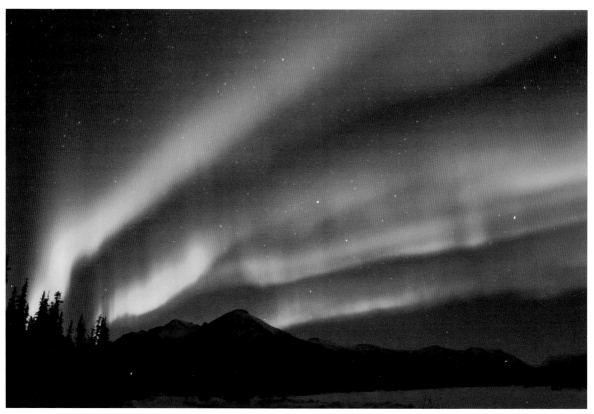

ISO 400.

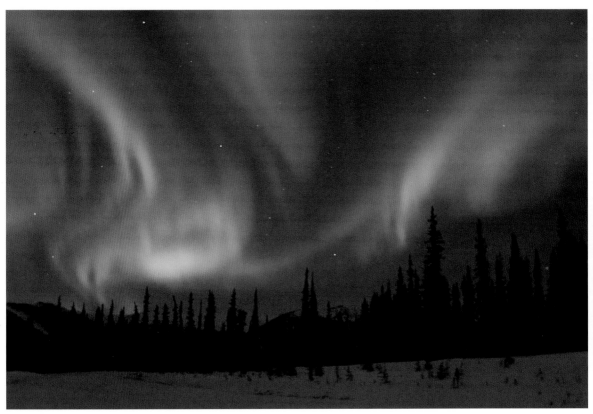

ISO 800.

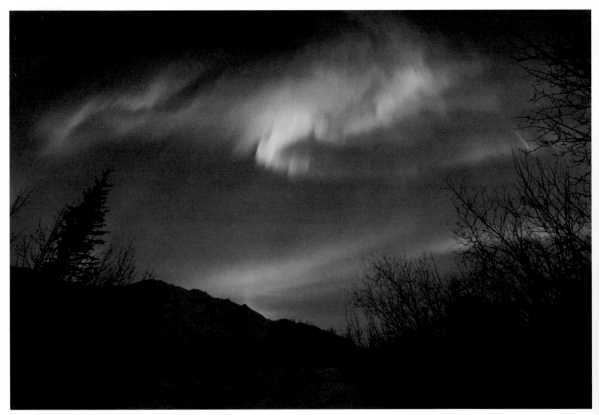

ISO 1600.

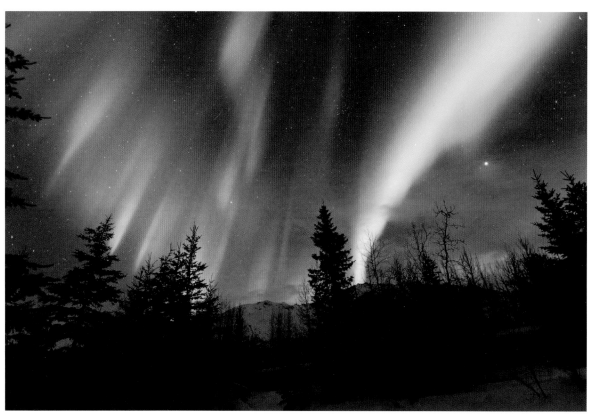

ISO 2500.

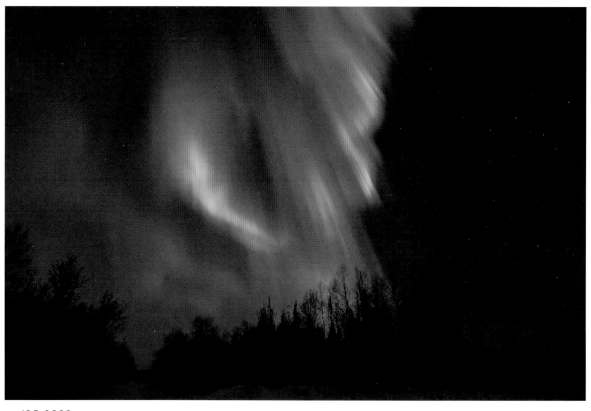

ISO 3200.

Noise and Noise Reduction

WHAT IS NOISE?

"Noise" is the term used to describe unwanted dots (equivalent to "grain" in the film days) that appear in a digital image. Noise might not be seen on the camera's LCD, but it becomes quite clear when an image is viewed at 100 percent on a computer screen.

Noise tends to be more apparent in the plain, solid areas of a subject, especially in the midtone and dark areas. Because the aurora is shot at night, the dark areas of the sky will show more noise than a winter scene of snow—even at the same ISO.

CAUSES OF NOISE

High ISO. Think of ISO as the volume knob on a radio. As you turn it up, the sound gets louder—but it also becomes more distorted, compared to the clean sound at lower levels. In a photograph, higher ISOs yield more distortion (noise).

Long Exposure Time. Slow shutter speeds introduce static, which can be a cause of digital noise. When photographing the northern lights, the ISO and shutter speed are the two main noise culprits because both are required in order to capture a photo.

Sensor Size. The smaller the sensor, the greater the noise. Larger sensors produce lower noise at higher ISOs. Most photographers shooting the aurora have a cropped sensor camera body. A full frame camera has a 24x36mm sensor; a crop sensor is usually 19.1x28.7mm (1.3 crop), 15.8x23.6mm (1.5 crop), or 15x22.5mm (1.6 crop). Notice the reduction in sensor size for these.

Pixel Size. This works hand in hand with sensor size. Assume we have a variety of 14 megapixel cameras. To fit that same number of pixels onto a smaller sensor, the actual pixel size has to be smaller. While many people want a camera with more megapixels for increased resolution, it is a trade-off; a camera with larger pixels (fewer megapixels) will actually perform better in low light. This is the main reason full frame cameras generally perform better in low light; they have larger pixels.

IN-CAMERA NOISE REDUCTION

Most photographers know the adage "use the lowest ISO possible for the best quality image." That isn't easy when shooting the aurora, as we've already discussed.

While slightly overexposing will help bring noise levels down, that isn't a good option for shooting the northern lights; it can blow out the highlights in bright parts of the bands. Likewise, it's more likely to see noise in high ISO files from any scene if the images are underexposed. To help offset the noise inherent to photographing the aurora, most newer camera bodies have two types of noise reduction options: high ISO noise reduction and long exposure noise reduction.

High ISO Noise Reduction. High ISO noise reduction evaluates the entire image to determine whether brightness variations at the pixel level indicate digital noise that can be smoothed out or subject texture/detail that should be preserved. Like many in-camera functions, this works only on JPEG files (not RAW files). If shooting in

both formats (RAW + JPEG), it will have the intended effect only on the JPEG. Postproduction work does a better job of eliminating this type of noise in RAW files. Multiple applications offer impressive noise reduction, so it is safe to forget about the camera's high ISO noise reduction setting.

Long Exposure Noise Reduction. When this setting is activated, the camera takes a second, identical exposure (with the shutter closed) for any shot longer than 1 second. This lets the camera know which pixels are hot and exactly how much light leakage there is. The camera then subtracts the dark frame image from the original shot, saving the result. Engineers call this "dark frame subtraction." The noise in the dark

frame exposure is examined and subtracted from the original image.

The downside is this causes the shooting and writing time to double, since *two* equal length exposures are being made. That can be an issue when the aurora is extremely active, since you'll only be able to take half as many shots.

Some believe that noise is the result of a heated sensor, so the cold temperatures of aurora shooting negate this and noise reduction can be ignored. This is more camera-specific, so tests on your personal gear are advised before choosing to activate this feature. My preference is to take more shots and do some postproduction clean-up of the ones I want to use.

Other Camera Settings

RAW VS. JPEG

A RAW file captures much greater depth of information than a JPEG file. For this reason alone, it is worth shooting in RAW whenever possible.

RAW is also a lossless format. When a JPEG file is saved on the memory card, the data is compressed and some pixels are taken away. When work is done later in another program, each save takes away more data and eventually the file has too many compressions and the quality loss will show—even on a computer. Because RAW files retain all the data, more work can (and must) be done in post-processing. Since there is no loss of data, this provides a very good file to print or post online.

Some people shoot in RAW + JPEG to save a copy of each file on the memory card.

This takes up more space, but the JPEG file is there for immediate use.

WHITE BALANCE

The most accurate white balance is generally achieved with a daylight or auto setting, although you may develop a personal preference to make the image warmer (cloudy setting) or cooler (custom 5000K). If you shoot in RAW mode, white balance adjustments can be made during post-processing.

A white balance settings menu.

IMAGE STABILIZATION

Turn off the lens image stabilization. The newest, more expensive lenses allow this to be turned on while the camera is on a tripod. When stabilization is used for long exposure times, however, the motor can burn out and require costly repairs.

SELF-TIMER

If triggering the shutter by hand, use the self-timer so any camera shake will cease before the shutter opens. A 2-second delay works best, if the camera has this feature. If the camera only has a 10-second timer, opt for a cable release or wireless remote.

LCD BRIGHTNESS

LCD review screens on cameras today are quite bright. To prevent a false reading when capturing a strong aurora, set the brightness to lower than the default.

Some cameras have an auto-brightness feature that measures the ambient light and adjusts the display. This is great for bright daylight settings, but it can be very misleading when shooting at night. The aurora may look great on the LCD but, on a computer, it is almost always underexposed. Turn this feature off and set it manually.

LCD brightness settings menu.

LCD REVIEW

Turn the review off so it does not come on after every shot. When you need to review a shot, to ensure the composition and exposure are correct, use the review button to look at the photo for a couple of seconds and then deactivate the display. Having the review come on after every shot uses up the battery. Also, the light it produces causes a loss of night vision for everyone nearby.

DRIVE MODE

Even though the continuous drive is normally thought of when you need to shoot many frames per second in wildlife photography, it is also a good mode for aurora photography. The main purpose for this is when doing continuous shots for stacking star trails or creating a time-lapse sequence where the remote is locked in and shot after shot is taken. If the action of the aurora is quite intense and moving very fast, numerous shots can be taken if the camera position does not have to be changed and the shutter speed is around 2 seconds.

EXPOSURE MODE

The two primary exposure mode choices for northern lights shooting are manual and aperture priority.

Manual Mode. Shooting in manual mode allows for complete control over both the aperture (f/stop) and shutter speed. The first setting to make is the aperture, which will be set wide open and left there all night. Next, the shutter speed can be set based on the shooting conditions.

The main consideration is the speed of the lens being used and the ISO the camera is set at. A good starting point for a slower lens and lower ISO is about 15 seconds.

Adjustments can then be made based on the brightness of the review. If using a high ISO, 10 seconds would be a good starting point to adjust from.

Throughout the night, adjustments to the shutter speed will need to be made based on the brightness of the aurora and how much it fills the sky. As the intensity of the aurora changes, check the LCD review to see how the exposure looks and make any needed shutter speed changes.

If there is a bright moon, your manual mode exposure times will need to be decreased so that neither the foreground nor the aurora is overexposed. Shooting in manual does take a bit more work in that exposures will need to be checked often if the intensity of the aurora changes frequently.

Aperture Priority Mode. Aperture priority is another option. Here, the shooter sets the f/stop and the camera automatically determines the shutter speed (within the mode's defined range). This mode works best if the shutter speeds are in the 5 to 15 second range. If the aurora fades a bit and a shutter speed of longer than 30 seconds is needed, the setting may exceed the mode's range and the photo won't be taken.

Because there is inherently quite a bit of darkness in an aurora composition, it's always best to add +1 stop of exposure compensation when shooting in aperture priority. Adjusting this up or down changes the shutter speed alone when using aperture priority. If you are not really familiar with doing these adjustments, practice a little before going on a trip.

METERING MODE

The optimal metering mode depends on the selected exposure mode. If manual mode is

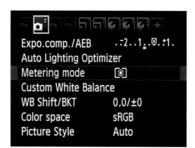

Metering modes.

used, the different metering modes do not play a part in determining the exposure.

When using any of the automatic exposure modes (aperture or shutter priority) to photograph the aurora, the best option is the evaluative metering mode. This will read the entire scene and not just part of it. If the aurora is quite bright in the center, another mode could lead to an underexposed image. Again, because there are going to be some dark areas in the composition, overexposing by about +1 stop is a good starting point. You can then make adjustments based on the aurora's brightness.

When working in manual mode and with evaluative metering, the scale in the viewfinder will show whether the scene is over- or underexposed—but that means having to look through the viewfinder and losing night vision when the light shines in your eyes to read it.

MIRROR LOCKUP

Most DSLRs offer a setting that locks up the mirror before the shutter opens to

take a photo, helping reduce camera shake during long exposures. Most of the mechanical vibration moving the camera is caused by mirror slap, so locking this up before the exposure helps improve sharpness. It is usually not required for wide angle images of the night sky, though. If the mirror lockup feature is turned on, pressing the shutter once locks the mirror; pressing it a second time fires the shutter. With the self-timer, most cameras will move the mirror when you first push the shutter button and the shutter will activate after the delay set. In this case, there is no need to press the shutter a second time.

AUTO-FOCUS POINTS

For most aurora photography, the lens is set for manual focus. If opting to use Live View for focusing, use the central spot; it is the most sensitive and accurate of all the focusing points. The same is true when trying to autofocus at night: select just the center focus point. Make sure to line up a star, the moon, or another bright light under this spot before attempting to autofocus. Every camera has a different layout for selecting focus points, but whatever the layout, select the center point.

Choose the center focus point.

VIEWFINDER

When photographing the aurora at night and in the cold weather, be careful not to breathe on the viewfinder; it will fog up eas-

ily. When looking in the viewfinder, be sure that the shutter button is not pressed. The bright displays for f/stop, shutter speed, frame count, etc. are useful, but they make it hard to see and compose a night scene. They also reduce your night vision temporarily. Make this mistake just once and it will be immediately apparent why it is important *not* to press the shutter button when looking through the viewfinder!

DATE AND TIME STAMP

Some photographers who travel a lot adjust the date and time stamp of their photos to the current location's time zone. While this is not a critical item to set, it can be useful to know exactly when a shot was taken.

COVER LCD LIGHT

Just about every camera body today has a red light that comes on during the exposure and writing of the image to the memory card. This light can both mess with your night vision and create problems for those shooting nearby. Placing some heavy, dark tape over this light can be very helpful.

CAMERA SETTINGS QUICK CHECK

- File format to RAW or RAW + JPEG
- White balance to auto or daylight
- Image stabilization off
- Self-timer to 2 seconds (if not using a remote)
- Decrease LCD brightness
- Drive mode to continuous
- Exposure mode to manual or aperture priority (manual is best)
- Metering mode to evaluative or matrix if using aperture priority
- Date and time stamp to current time zone
- Cover the LED write light

Sensor Check and Cleaning

A dirty sensor can ruin a perfectly good aurora shoot. While spots can be removed in post-processing, it's better to get rid of them before the shoot ever starts. This is a problem digital photographers have had to deal with since the early days of DLSRs.

Spots get on the sensor when changing the lenses. The best way to avoid constant problems is to make sure the camera is turned off before changing lenses; this deactivates the sensor so it does not act like a magnet. Also, have the new lens ready to go on the body and get it placed there *before* worrying about getting caps in place and putting the first lens away.

There are a couple of ways to check for sensor spots. The easiest is to take a photo of something solid in color, like a clear blue sky. Zoom in and see if there are any of those annoying spots. Another way to look for spots is with a viewing tool like the Delkin SensorScope. To use this, set the camera to manually clean the sensor. When the shutter button is clicked, set the device on the opening, as if it were a lens, and press the button. A light comes on to allow for viewing the sensor. The device has 5x magnification, so it does a great job of showing any dust spots that just won't go away. Even on cameras with automatic sensor cleaning, there can be obstinate spots.

There are several options for cleaning the sensor. Many photographers do not want to have anything to do with trying to clean the sensor themselves—and this is understandable. The thought of damaging the sensor causes dollar signs to flash in front of their eyes.

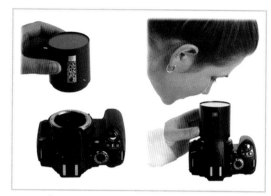

Using the Delkin SensorScope.

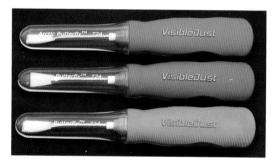

Arctic Butterfly by Visible Dust.

Rest assured, though, cleaning a sensor is very easy and safe. When I go through the cleaning process, the first tool I use is the Arctic Butterfly by Visible Dust. They have a good line of products for cleaning sensors and their latest model shines a light on the sensor.

If this fails to get the spots off, it's time to bring out the liquid cleaner. The combo I have been using for quite a few years is a drop or two of Eclipse Cleaner on a Pec Pad cloth wrapped around a spatula swab. Most camera stores have these items and will know what you are asking for. (Another good use for the Eclipse Cleaner is to instantly defrost a lens that has been frozen when brought indoors from the cold. Since

it contains methanol it will instantly clean the frost off of a frozen lens element.)

Years ago, some people used a LensPen to clean their sensors. In fact, this is what Canon used at one time when people sent their camera in for cleaning. If using the original LensPen, tap it on the table to remove any carbon from inside the cap. The company now sells a device specifically designed for sensor cleaning.

Eclipse Cleaner and Pec Pads.

Know Your Camera

With northern lights shooting, it is especially important to know your camera and how to make changes quickly, since the dark conditions make it tough to see the buttons and controls. As noted, it's best to be able to do this without a flashlight to minimize your impact on other shooters and maintain your night vision.

The following are the main buttons and features to know how to find and push while it's dark outside—and when wearing a pair of glove liners (remember, you don't want to spend too much time handling the camera with your bare hands). Being able to do a quick push of the review button with thick gloves is also useful.

- Image review button
- Which way to turn dial to change shutter speed
- Button and dial combo for ISO change
- White balance setting
- Motor drive
- Changing a battery
- Changing focal length of a zoom lens without changing the focus ring
- Control panel illumination button

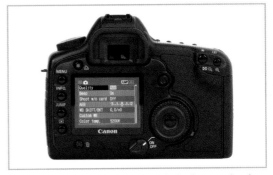

Practice your camera's controls before embarking on an aurora shoot.

After the camera has been out in the cold, there can be a delayed reaction to some changes, such as adjusting the shutter speed (this is also a good indication that the battery is losing power). It could take a moment before the change appears on the LCD, so knowing which way to turn the dial will help ensure it is set correctly.

If your cable release freezes up, you should know how to take it out and switch the camera to the 2-second timer. Happily, most cameras now have this instead of just a 10-second timer. It's disappointing seeing a good display in the sky while waiting 10 seconds for the shutter to open. The best shots could be over by then.

Shooting the Aurora

Focusing Your Lens

The most critical step for a night of aurora photography is getting the lens precisely in focus. Getting a *close* focus is not going to work; the foreground subjects will look soft and make the whole image look bad. It is acceptable for the aurora to look soft at its edges, but the foreground must be sharp.

One of the ways to get it *wrong* is to turn the focus ring to the infinity mark and leave it there. In all my years of leading northern lights workshops, I've only seen a few lenses where the infinity focus was right on the infinity mark. For some reason, it is just a little off. The following are three ways to obtain a good infinity focus.

SET THE PRE-FOCUS USING AUTOFOCUS

1. Before it gets dark, go outside with the lens set to autofocus. Set the camera to single-point focus on the center square. Focus on something a good distance away. Make sure it has contrast (like a mountain ridge and skyline). A good test is to get a focus on something close (10–15 feet) and then on the distant subject to make sure the focus distance doesn't change on the lens. Most camer-

as have a light inside the viewfinder that indicates when focus has been obtained. Make sure this has triggered, showing focus has been achieved.

2. Once you have the focus, switch the lens to manual focus.

3. With the set focus, take several shots of a distant subject and then on something about 20 feet away. Look at the images on the LCD to make sure both are in focus. Enlarge them if necessary. If they are not sharp, turn the lens back to auto-focus and repeat the first two steps.

4. Take a look at where the infinity line/ symbol is and where the lens lines up for future reference. More than likely, this is where infinity is all the time. If the lens somehow gets off of this, it can be used as a starting point.

5. Cut off a piece of the white tape mentioned earlier and place it on the lens so it overlaps the focusing ring and lens barrel. This will make sure the focus stays in place and isn't accidentally moved when you change the focal length of a zoom lens.

Focus on something a good distance away with contrast.

A piece of white eletrical tape over the focusing ring and lens barrel keeps the focus locked.

These steps will need to be redone each evening if the lens is used for other shooting throughout the day.

GET A NIGHTTIME FOCUS

If the focus gets off during the night (or if you forget to get a pre-focus), there are several options for getting sharp images.

Ambient Light. Depending on where you are shooting, there may be a cabin or vehicle nearby. Go to one of these and turn on a light inside. Position yourself about 10 yards away and use the center focus square to get a focus on an area where there is contrast between the light and dark areas. If this is not convenient, a strong flashlight can be used to illuminate a tree, cabin, or other structure. As with the steps for getting a pre-focus, take a shot and review it to make sure there is a good focus.

Live View Focus. Many newer camera bodies have a feature called Live View where the LCD screen (rather than the viewfinder) projects the image. To use Live View to obtain a focus, follow these steps:

1. Turn off autofocus on the lens and turn on Live View on the camera.
2. Set the lens to the infinity mark, to be near the point where sharp focus will be.
3. For the next step, there are a couple of ways to go about getting a focus.
 A. Find an object in the foreground about 20 feet away and illuminate it with a flashlight. If you can't see it well enough, move a little closer or use a stronger light. Zoom in as far as possible on the illuminated object via Live View (not with the zoom of the lens). On a Canon camera, this is accomplished by using the buttons with magnifying glasses and +/– symbols on them. Holding a flashlight in one hand, use the other hand to adjust the lens manually until sharp focus is obtained on the subject.
 B. The second option is to find the brightest planet/star and place it in the center of the frame. Adjust the exposure until the dot is visible and zoom all the way in. If the dot is too bright or has a halo, reduce the exposure slightly. Manually focus the lens until the star looks sharp. If there is a little bit of moonlight, try focusing on a snowy mountain ridge or another object where there is some contrast—or focus on the moon itself.
4. After focus has been obtained, turn off Live View, take a couple of images (close and far) and review them to make sure they are sharp.
5. As with setting a pre-focus, tape the lens so the focus is maintained.

SET THE HYPERFOCAL DISTANCE

A final way to set lens focus is to use the hyperfocal distance. This is defined as the closest distance a lens can be focused while keeping objects at infinity acceptably sharp. When the lens is focused at this, all objects from half of the hyperfocal distance out to infinity will be sharp. There are two ways to find out what the hyperfocal distance is for the wide-angle lens being used.

First, you can use a handy SmartPhone app called DOFMaster, which walks through the steps for obtaining precise focus. This allows you to select the precise camera body, the focal length of the lens, and the f/stop. It then does the calculation and gives the hyperfocal distance. Manually focus to that point, and halfway between that out to infinity will be in focus. Because

some of the distances exceed the lens's scale, shine a light on an object at that distance to get the focus. For example, for a Canon 5D body with a lens set at 20mm and the aperture at f/2.8, the hyperfocal distance is 15.5 feet. Focus at that and from 7.75 feet to infinity will be in focus. If you will be using the same focal length all night, this is a good way to get the focus.

The second way to do this is by creating a chart from numerous online sites that provide the info needed. One is from the maker of the phone app and can be found at www.dofmaster.com/dofjs.html.

The only problem with using the hyperfocal distance is when using a zoom lens for shooting the aurora. When you change focal lengths, the focus will also need to be changed. Along with doing a test shot for every change, this can lead to a bit of extra work and some lost time when the aurora is active.

Setting the Correct Exposure

If you look at the online charts regarding the "proper" exposure for shooting the northern lights, you'll find that there are as many different settings as there are charts. Below are what I found in three different articles about the "correct" shutter speed for ISO 800 at various f/stops.

	ARTICLE1	ARTICLE 2	ARTICLE 3
f/1.4	10 seconds	3 seconds	6 seconds
f/2.0	20 seconds	6 seconds	15 seconds
f/2.8	40 seconds	15 seconds	30 seconds
f/4.0	80 seconds	25 seconds	

The numbers are all over the place. If you rely only on one of these charts and use their settings exclusively, the chances for lots of good shots will diminish. There will be some good shots with these settings but not as many as there could be.

A BALANCING ACT

So, what is the "proper" exposure? That depends. If the aurora didn't move and maintained the same brightness, getting an optimal exposure would be simple. All it would take would be setting the camera to aperture priority and center-weighted metering. A test frame might show that some exposure compensation could be used, but the guesswork would be eliminated.

Unfortunately, the aurora is always moving and shifting from low on the horizon to directly overhead. Then there is the changing brightness factor. Because of this, there is some compromise to determining the "right" exposure. The aperture needs to be wide open to allow for the fastest shutter speed to freeze the movement, but you also need a long enough shutter speed to get the brightness properly exposed. If the moon is out, compensation is needed for its brightness, especially with snow on the ground.

Then there's the third variable working together with aperture and shutter speed: ISO. On the plus side, the higher the ISO goes, the faster the shutter speed can be. The minus is that you'll also get more noise and have less room for error in getting a proper exposure without much cleaning up in post-processing. (While there is latitude for adjusting the exposure in postproduction when shooting in RAW, the exposure

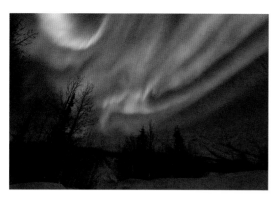
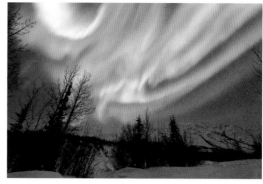
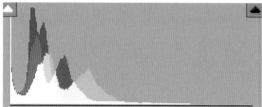
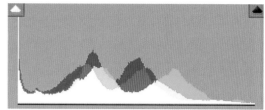

LEFT (TOP AND BOTTOM)—This is the exposure and histogram right out of the camera. The image was shot at ISO 2000, f/2.8, and 2.5 seconds. Notice the separation seen in the curtain along the top left. The clipping on the dark (left) side of the histogram is from the silhouetted foreground trees. There will be some of this in just about every aurora photo. **RIGHT (TOP AND BOTTOM)** This is the exposure and histogram after adjustments were made in Adobe Camera Raw to center the histogram to what some would think is a "proper" histogram. While there is brightness to the snow, some areas of the aurora are too bright for presentation. All photography is subjective, but to me the exposure is a bit harsh—especially the area in the upper left-hand corner. Somewhere in between these two (with moving the exposure slider) would be the best result.

can't be increased much without introducing more noise.) I recommend testing your camera and lens combo at several ISOs at night *before* your trip to see what looks acceptable. See how much noise is produced at 800, 1000, 1200, 1600, and 2500.

YOUR FIRST SHOTS

For your first aurora shots, use the highest ISO your tests showed to be acceptable or go one step lower to help mitigate the noise. If this is around ISO 1200, start in manual mode with a test exposure of 10 seconds at f/2.8. Gauge the brightness of the aurora and, after looking at the LCD review, adjust the shutter speed accordingly. If you are using the aperture priority mode and letting the camera pick the shutter

speed, adjust the exposure compensation as needed from the +1 starting point.

As the aurora intensifies and weakens throughout the night, the shutter speed will need to change with it. Periodically check the review to see what the shots look like.

USING HISTOGRAMS

Some web discussions talk about relying on the histogram to get the correct exposure.

Unless the sky is completely filled with the aurora, there will be a good bit of darkness in the shot and the histogram will be skewed more to the left of center than centered or to the right. If you try to get the histogram centered, the image will be extremely overexposed. (More on histograms in the next section.)

The Aurora Histogram

Everything you've learned about reading histograms goes out the window when photographing the aurora. That perfect bell curve may not result in the best image. When shooting the aurora, most of the histogram will be to the left of center, since there will be more dark elements than light elements in the photo.

The peak at the left-hand side of this histogram shows the pixels in the dark area of the foreground. They have a very similar value and are almost completely black. The second, broader peak covers the larger number of pixels across the sky in areas not containing the aurora.

While this is still in the darker half of the histogram, it is clearly separated in brightness from the foreground. As you can see in the areas where the sky meets the trees, the night sky is not completely black.

To the right of the broad peak for the night sky, there is a flattened area that represents the brighter pixels of the aurora. The aurora is certainly a "lighter" feature of the night sky, but not compared to the bright white of a cloud in a daytime image. An element like that would bring peaks to the right hand side of the histogram. While the lightest area of this aurora is quite bright, it represents just a small percentage of pixels in the image, so it barely shows up in the histogram. Therefore, the right hand side of this histogram in this case is mostly flat and concentrated in the middle.

If using the histogram in the field as a gauge, having some pixels throughout this middle one-third of the graph can be helpful, since it shows there is enough in the midtones to work with.

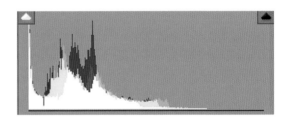

An image and the corresponding histogram.

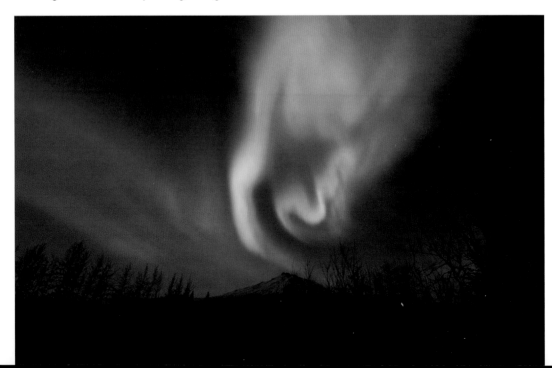

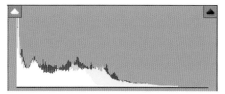

The histogram shows a very good balance for an aurora image. There is a peak to the darks from the trees in the foreground, but the remainder is very balanced, as the aurora fills most of the sky with a little snow at the bottom. The brightness of the aurora has good separation due to slight variations in the color and intensity allowing the curtain to have separation.

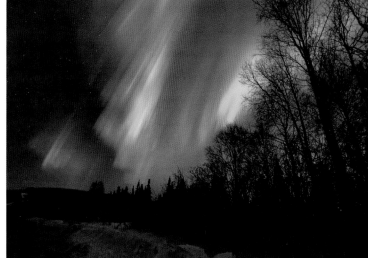

BEFORE—While this histogram looks good for an aurora image, the brightness to the lower portion of the aurora on the left is a bit too much. It pulls the viewer's eye there and away from the reds and the nice tone of the green on the right.

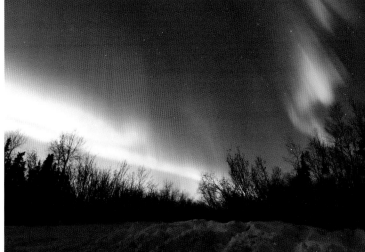

AFTER—After adjusting the Tone Curve in Camera Raw and adding a little bit of Saturation, the area of extreme brightness was toned down to create a balance in the overall aurora. Bringing down the Lights and Highlights in the Tone Curve helped the aurora; it also took some white off the snow in the foreground. There are always trade-offs in post-processing.

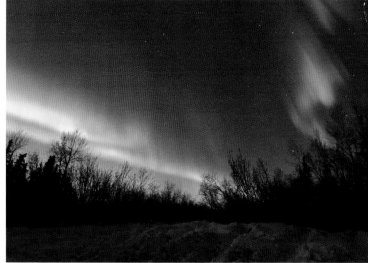

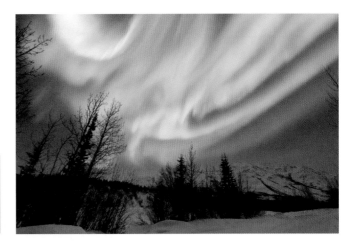

BEFORE—A perfect histogram, but not for an aurora. This image is very overexposed. With the moon out and the aurora getting brighter, the abundance of light almost makes this look like it was shot during the day because of the white snow and nice sky. When going through images, this would seem like an obvious deletion because of how poorly exposed it looks. If there wasn't a lot of shape to the activity, this might be the case; however, with some adjustments, this image can be recovered and yield a good result.

AFTER—This image is now usable, even though the histogram is mostly to the left of center. The snow is still white, there is darkness to the sky, and the aurora has good color. In Adobe Camera Raw, I lessened the Exposure a good bit and increased the Blacks, Clarity, Saturation, and Luminance a little bit. More on this in the post-processing section of the book.

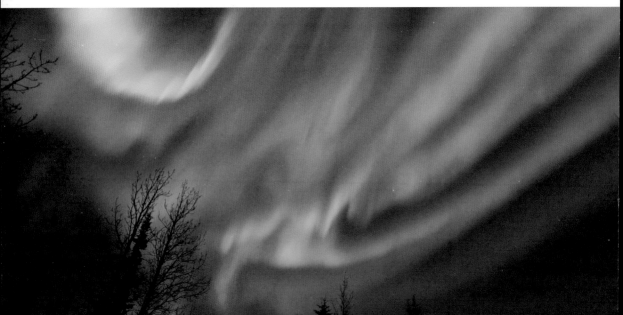

You Don't Know What to Expect

When shooting long exposures of the aurora borealis, it's impossible to know exactly what to expect when you later look at the image on a computer. Just like a child can lie on the ground and try to envision objects in the clouds, we can often see shapes suggested in our shots of the aurora.

If the aurora is moving really fast and going all over the place, the imagination can run wild over what is seen—or a very plain object might come into view. These multiple movements and shapes are precisely why so many shots should be taken while it is active. No two will be the same.

Even with using a high ISO and a shutter speed of just a couple of seconds to freeze the action, the resulting shots can still amaze, since the eye sees a continuous flow of action rather than frozen moments in time. That is one of the best things about shooting the northern lights: you don't know what to expect.

Let your imagination run in the next few images and think of what you see in each of the shots. After the last photograph, I've listed what I see in each one. How many will we agree on?

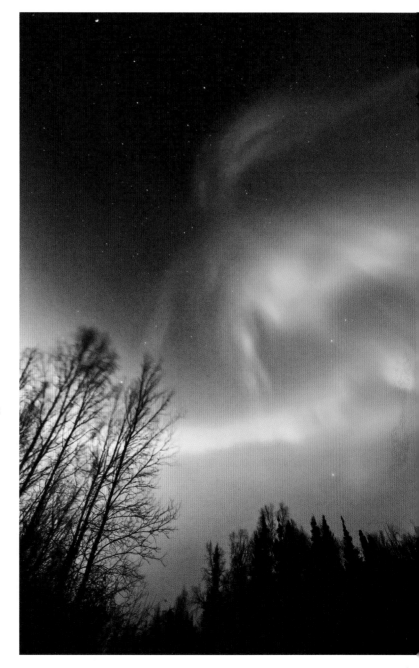

What do you see in this shot? I'll share my impression on page 77.

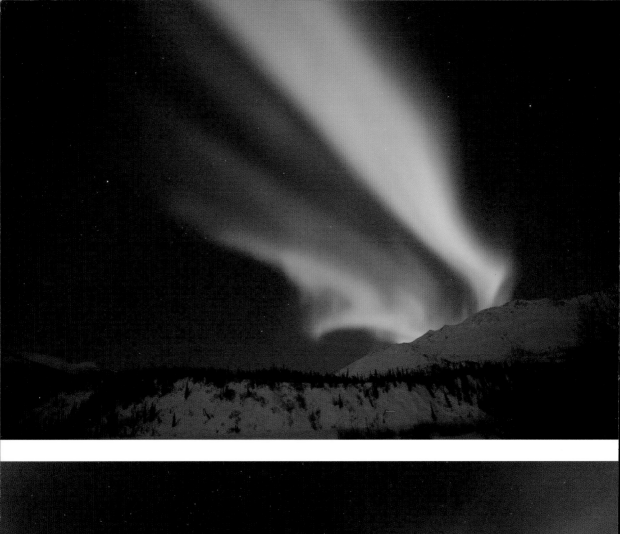

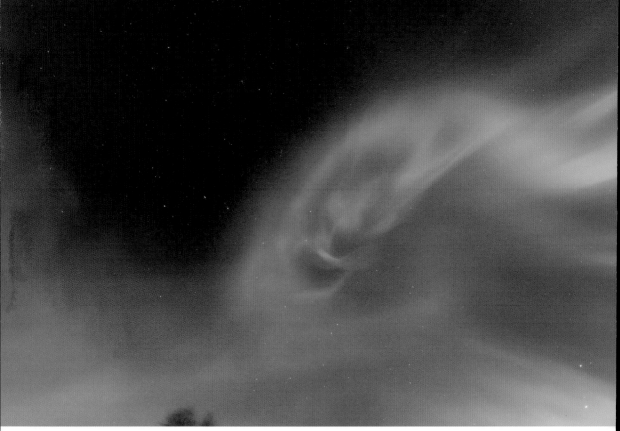

PAGES 75–77—I call the first shot (page 75) *Surfer Boy*. I see a head, long flowing hair, a body and arm, and a surfboard at the bottom. The next image (page 76, top) is *Shark Attack*. I see the open mouth and teeth and the outline of its head. At the bottom of page 76 is *Ghost Face,* with the eyes and mouth peering down at us. In the photo to the right, can you see why I call it *Bighorn*?

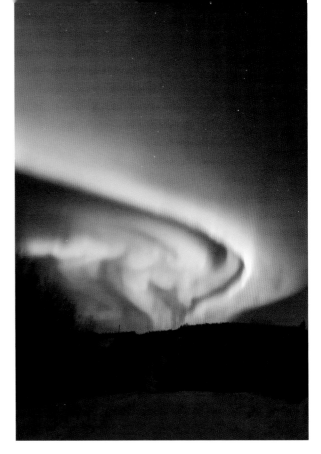

BELOW—A 2-second exposure froze the movement of the aurora and provided detail that was not visible to the eye when observing the aurora as it danced around

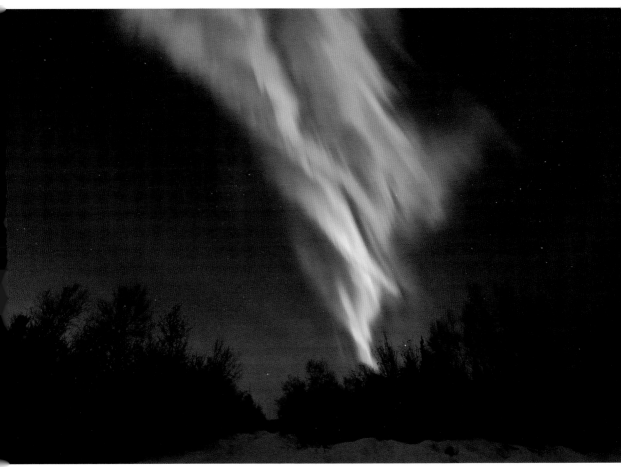

Planning

Most people's brains don't work their best late at night. This is compounded by the cold temperatures involved in aurora photography. Therefore, the simple act of thinking things through and formulating a plan for a composition and camera settings will make a big difference in your images.

Getting ready for night-sky photography involves thinking about the location and where in the sky the aurora should be active. Here are some things to consider:

THE LOCATION
- Which locations give good views in multiple directions when the aurora gets active to both the east and west?
- Which directions have the darkest skies (when shooting in areas with any kind of light pollution)?
- Where to park? Will the vehicle be in the shot or cause light problems if someone has to get into it?

- Does the area have more than one good foreground to incorporate?
- Can any bad foreground elements be worked around or eliminated in post-production?

THE SKY
- If there is a moon, what time does it rise and when will it crest a nearby ridgeline? Where will it be in the sky?
- Is the Milky Way visible? In which direction? Can it be incorporated with the northern lights?

LOCATION SCOUTING
Exploring potential locations during the day can make life much easier when going there to shoot at night. Finding the easiest way to get access and exploring different angles during daylight hours can save a lot of precious time.

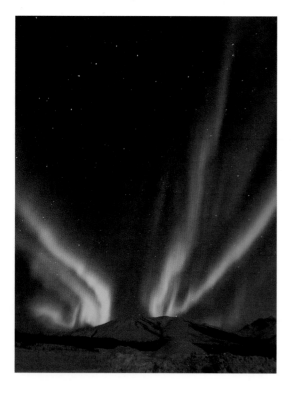

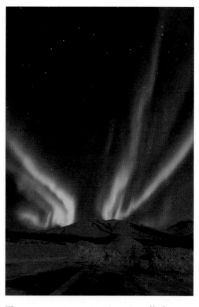

There was a great view in all directions, but one area had poor foregrounds with plowed snow piled up (above). A little cropping cleaned up the shots in that direction (left).

Finding a good foreground subject is more important in northern lights photography than with other landscape photography. Unless the shot is directly overhead (like a corona forming), some type of foreground is always needed to provide a contrasting element in the composition. It is very rare to see a photo of just an aurora with nothing else in the frame unless the aurora has some great form to it directly overhead.

While the aurora is the main subject in the photo, a good foreground can make or break the shot. It can add impact or take away from the shot, especially if the aurora is not very strong.

As with most landscape photography, you will need to do a lot of moving around. You want to find just the right composition with foreground and background subjects that work together. Familiarity with the area will help in finding good foregrounds, as will taking some time during the day to scout for potential compositions. This is key to coming away with strong images.

The shape and orientation of subjects in landscape photography help determine if the orientation should be horizontal or vertical, and the same rules apply to the northern lights. Because activity is often lower on the horizon (depending on how far north the location is and the position of the aurora), it typically lends itself to a horizontal format. The foreground subject can cause a switch to vertical, especially if the aurora is taking up a lot of the sky. That was the case is this image of the trees. Also, if the auroral band is directly overhead, a good vertical can be created.

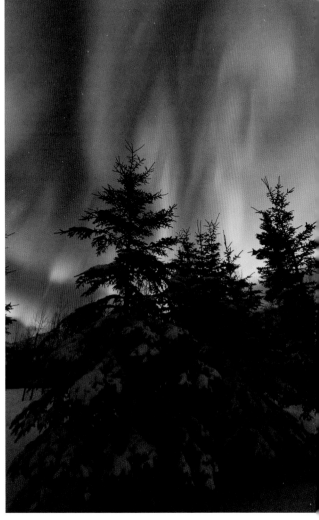

The foreground trees make this a natural for a vertical composition.

Because the aurora is located in high latitudes, there are usually mountains nearby. These make for a good anchors in the foreground, but trees and cabins are also great secondary elements.

Wherever you set up for aurora shooting, make sure to move around and get different foregrounds so the images have a variety of looks.

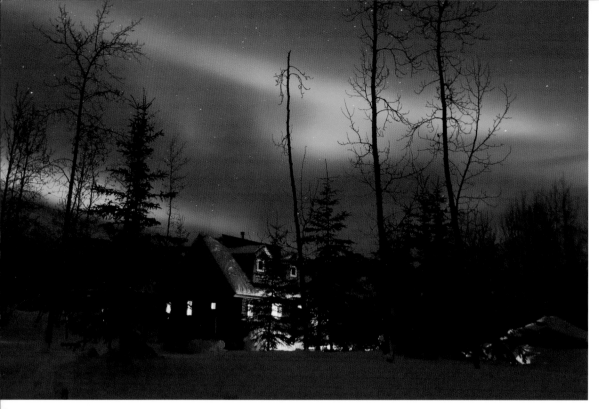

ABOVE—When the aurora does not have strong colors and shapes, finding a good foreground is important. Usually, the aurora will be the strongest element in the image. However, it can also play a secondary role, as in this scene with the beautifully lit cabin.

BELOW—Mountains make for a good base to the aurora borealis. But don't let the beauty of the aurora captivate you; remember all the basic compositional rules when taking your photos. Here, the rule of thirds is basically followed. However, because the sky holds the stronger part of the scene, a bit more of it (rather than the foreground) can be included in the photo.

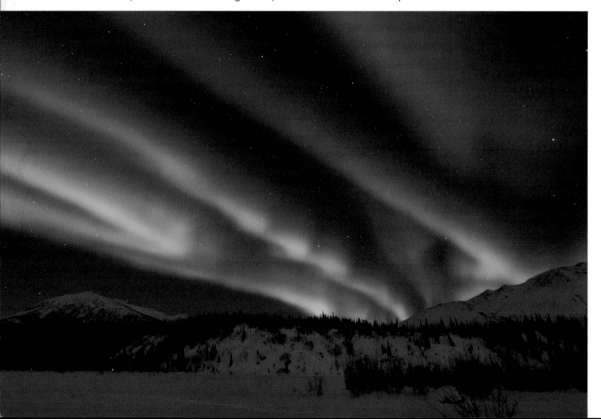

In the course of a night of northern lights photography there will be numerous times when things change in terms of the composition and the aurora's brightness.

It could take several tries to get the composition just right when moving to change foregrounds. A few test shots might also have to be taken to get the horizon level and the elements lined up properly. (Some cameras now have a built-in level that can make this much easier.) These tests can be used to ensure there is not too much foreground and that the aurora remains the main emphasis.

Along the same lines, you should periodically check the LCD review as the brightness of the aurora changes. Throughout the night, it will fade and intensify, and your shutter speeds will need to be adjusted to compensate. With experience, it will become easier to gauge how much change in shutter speed is needed. When a good breakup starts and the aurora gets brighter, do a test with the current shutter speed, make an adjustment, check again, and then fine-tune the speed to get it right for the rest of the breakup display.

TOP AND CENTER—As the aurora kicked in with more color and brightness, I took the top photo at ISO 2500 at 6 seconds. Wanting more curtain definition, I dropped the exposure to 4 seconds for the second photo.

BOTTOM—When changing your shooting direction, shoot a test image and check it on the LCD. Then make adjustments as needed. If you can see well through the viewfinder (and your instincts can be trusted), go with that if the aurora is really active.

Leaving the shutter speed at one setting for the night will cause a loss of shots; there will be some that end up overexposed and some underexposed. Some shots can be recovered in postproduction, but some images will be too far gone for recovery.

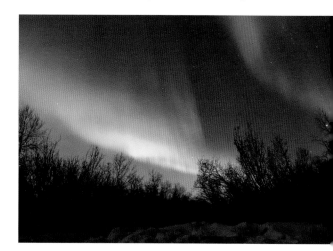

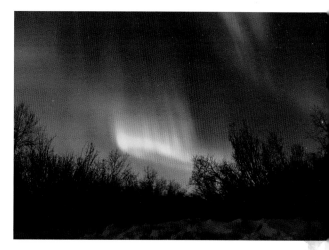

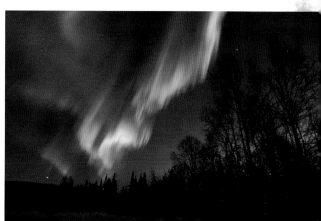

Accentuating Form

What makes a *good* shot a *great* one? Often, it's a handful of basic things put together in a conscious manner. Good composition is key to drawing viewers into a photograph and defining the point of interest.

Some of the strongest design elements of composition are lines. In the facing-page image, there is a strong feeling of line as the bands of the aurora are positioned to look like they are coming out from the tops of the trees.

Lines can be very important in helping the viewer to work their way through the photo and understand the photographer's intent.

Without lines, many of the other elements, such as shape or shadow, can't exist. Without shape and shadow, there can be no form to the image. Of course, the aurora itself also has the impact of color and the potential for creating an abstract image.

Props

Photography, especially of wildlife and nature, has evolved toward favoring more natural settings. Some would think this means leaving props in the past, but we just can't help wanting to add a little extra something every once in a while. Accordingly, there are lots of aurora images with city skylines, old cabins, and other elements in the foreground.

As an aurora photographer, the logistics of getting something extra in an image and having it look natural can be a bit complicated, particularly with the hassles of taking extra luggage to the airport to carry these items. If it's done right, though, a little something extra can add a lot to the shot.

Photographing the aurora with props comes down to one basic concern: how do you make element A interact with element B? With this photo (right), the tent situated out in the wild is far from out of place, even in the snow—since many people camp during the winter. The perfect touch is the

tent being green to match the green of the aurora.

Even though it was totally staged, the green tent fits naturally. In addition, it adds an interesting foreground subject that has caused many people to ask if I actually was using the tent to camp out at this spot.

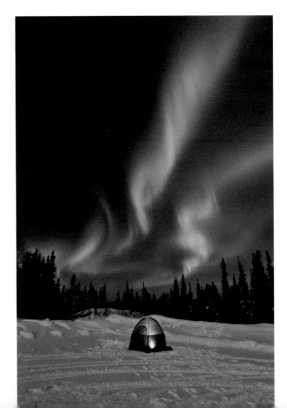

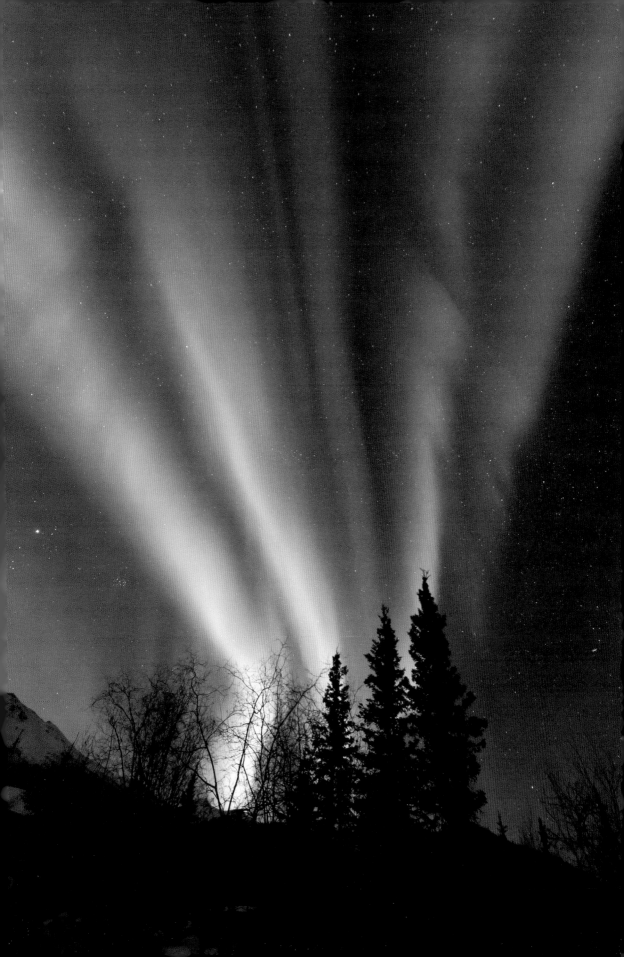

Light Pollution _____

Light pollution, a brightening of the night sky due to street lights and other man-made light sources, can disrupt the observation of stars and the Milky Way. Because the aurora is just 60 miles above the Earth, the amount of light pollution needs to be very strong in order to completely block out the view. In areas where there is a moderate amount of light pollution, it does have a bit of an effect—but not all of the time. However, there are some places where the night sky light pollution makes it hard to see the aurora even when it is strong enough to reach that area on a given night.

The areas where the aurora is strongest (in the auroral band) tend to be situated away from major producers of light pollution. There are cities within the auroral band that put out a bit of light, but the strength of the aurora in these spots means that the light pollution does not preclude viewing it—even if it's a bit dimmer.

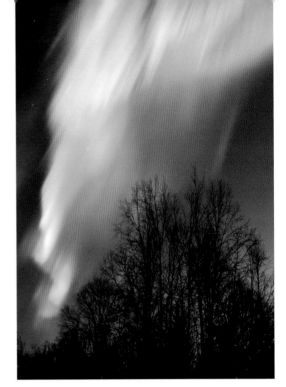

ABOVE—There are times when picking up light pollution from a nearby city is unavoidable. Depending on the color of the glow, however, it can actually appear to be part of the aurora. The rose color on the right side of this photo is the result of city light haze from Fairbanks bouncing onto some clouds hovering over the town. Because of the terrain, there can be clouds over the city but it will be clear a few miles north where the elevation rises.

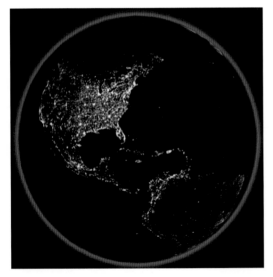

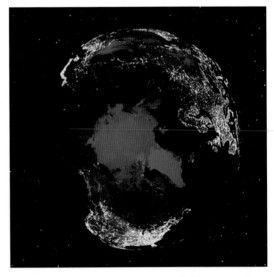

These globes show where the major amount of light pollution is in the United States (left) and in the northern hemisphere (right).

There are also times when the aurora is so strong that the nearby city lights do nothing to obscure the colors, bands, and curtains. Fairbanks, Alaska, and Reykjavík, Iceland, are good examples of cities where the light pollution has little to no effect on the visibility of the aurora.

Also, depending on where you are situated when photographing the aurora, the city lights may be seen in the photo or they may be behind the shooting position. There are times that mixing the light pollution and the aurora can actually create an interesting effect.

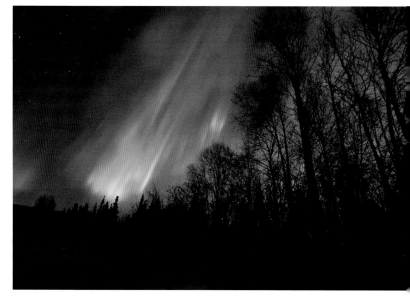

RIGHT—This image was taken just 12 miles north of Fairbanks, shooting to the southeast. There are still strong colors in the aurora but it would have been even stronger if there had been no light pollution (evident through the lower part of the trees on the right side).

BELOW—This image was shot from the same location as the previous image but in a north-westerly direction. Shooting away from the city lights intensified the aurora and made the sky a bit darker.

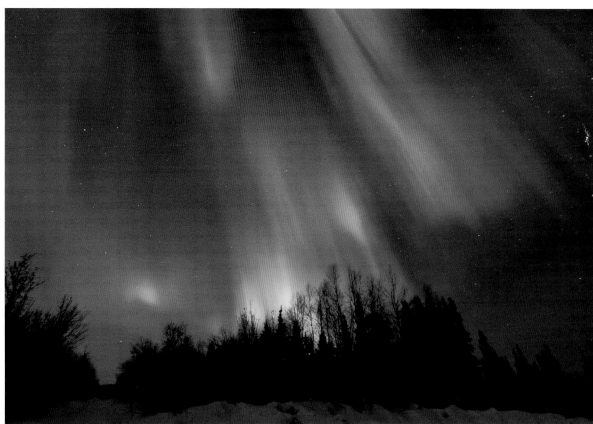

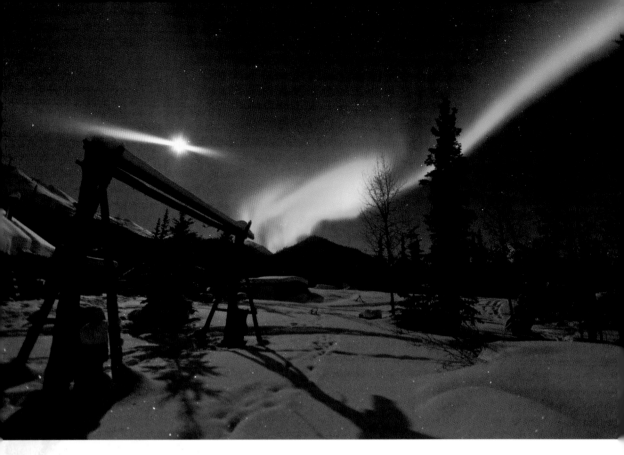

The Moon and the Aurora

Whether or not to photograph the aurora when the moon is out is a question everyone has to ask when planning a trip to shoot the northern lights. Some people don't want anything to do with a full moon phase and want the sky to be totally dark during a new moon; others love the effect the moonlight has on the foreground subject. I'm in the second group.

There are some things written about how the moon takes a lot away from the intensity of the colors of the aurora during the night. There is some truth to this, but the moon in the sky can also enhance your aurora images in very interesting ways. For example, if you are visiting an area in the spring, when there's a good bit of snow on the ground, the moonlight will reflect off it

and add shadows and detail to everything in the foreground.

Just because a full moon is scheduled doesn't mean it will be out all night, every night, for the days leading up to it and the few days afterward. The sun does not crest the horizon north of the Arctic Circle for part of the winter and stays up continuously during the summer—and there are also times when the moon does the same. From experience, I know that there have been times (just a day or two after the full moon) when it did not rise until close to the time we were finished shooting. There have also been days when the moon did a complete circle just above the horizon.

When the moon is out, exposure times need to be decreased a little bit so as not

to overexpose the moon, the aurora, or the foreground. Conversely, longer exposures are required when the sky is dark (around the new moon phase).

If the moon will be visible, check the moonrise and moonset times for the location being visited for the shoot. I spent a month in Alaska and photographed during every moon phase, capturing good shots during each variation. The aurora does not wait for the moon; if there's a great display going on when the moon is out, shoot with what is provided. Use the moon as an advantage to light up the foreground and make photos that are more interesting because of its presence. Use light angles to create shadows from different directions, just as when working with sunlight during the daylight hours.

When shooting without the moon near or above the horizon, keep in mind that the foreground subjects are going to be recorded mostly in silhouette. Look for situations where the foreground shapes are strong enough to carry the base of the photo.

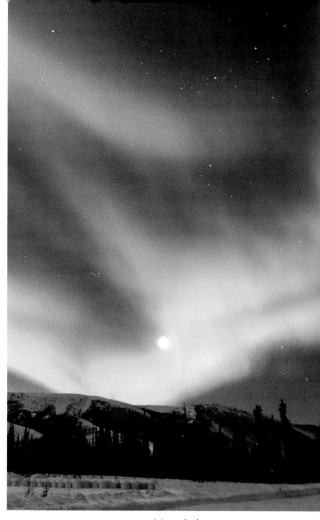

FACING PAGE AND ABOVE—Moonlight can produce interesting effects on the foreground.

Moon phases. *Image courtesy of www.astronomy.ohio-state.edu.*

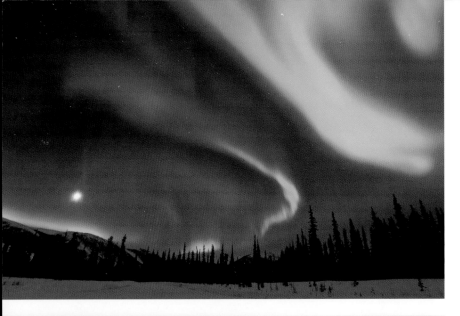

This moon was actually a little less than half full, but the longer exposure makes it look round. If it had been a full moon, there would have been even fewer stars visible in the sky. The partial moon was still enough to put nice light on the foreground and bring out the snow.

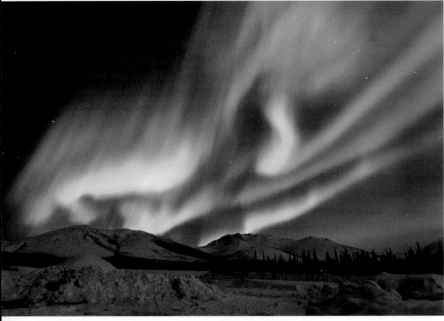

The moon was just below the horizon in this image, but there was enough light from it to bring out the white of the snow on the ground and mountains. The red that appears at the top of the curtain on the left side shows that the moonlight doesn't necessarily take away from the color and intensity of the display.

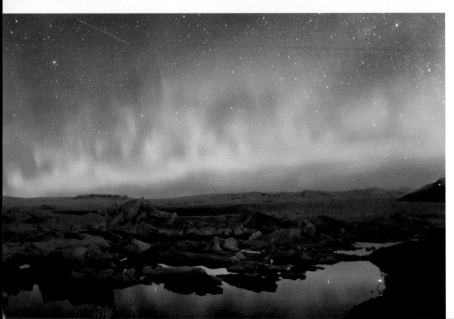

When the moon is not present in the sky, the foreground subjects are not lit up; shape is what needs to be accentuated to have a good anchor for this portion of the shot. The stars helped show the lack of a moon in this shot at Iceland's Jökulsárlón, a glacial lagoon. In post-processing I used the Shadow slider in Tone Curves to help bring out the detail in the ice chunks.

Moon Phase and Time Sample

Where there are dashes for moonrise times, the moon rose the day before. Notice the rise time gaps each day. Unlike most of the United States where rise times are usually about 30 to 40 minutes later each day, in Alaska the times can be more than an hour each day and up to an hour and a half. As shown, just a few days after the full moon, it does not rise until after the normal time for aurora activity to be finished for the night. For those not wanting to spend a week in these locations because of the problems a moon might cause, take note that it really doesn't effect the images.

FIRST-QUARTER MOON THROUGH THIRD-QUARTER MOON
FOR MARCH 2014 WITH RISE AND SET TIMES FOR FAIRBANKS, ALASKA

DATE	MOONRISE	MOONSET	ILLUMINATED	PHASE
Mar. 8, 2014	- 9:58AM	4:01AM	56.1%	First Quarter at 4:27AM

Note: hours shift because clocks change forward 1 hour for Daylight Savings Time.

DATE	MOONRISE	MOONSET	ILLUMINATED	PHASE
Mar. 9, 2014	- 11:51AM	5:49AM	65.7%	
Mar. 10, 2014	- 12:54PM	6:23AM	74.6%	
Mar. 11, 2014	- 2:05PM	6:47AM	82.5%	
Mar. 12, 2014	- 3:21PM	7:04AM	89.3%	
Mar. 13, 2014	- 4:39PM	7:17AM		
Mar. 14, 2014	- 5:59PM	7:27AM	94.5%	
Mar. 15, 2014	- 7:20PM	7:36AM	98.1%	
Mar. 16, 2014	- 8:42PM	7:45AM	99.8%	Full Moon at 9:09AM
Mar. 17, 2014	- 10:06PM	7:54AM	99.4%	
Mar. 18, 2014	- 11:32PM	8:04AM	96.9%	
Mar. 19, 2014		8:17AM	92.1%	
Mar. 20, 2014	12:58AM	8:34AM	85.3%	
Mar. 21, 2014	2:22AM	9:00AM	76.5%	
Mar. 22, 2014	3:3AM	9:38AM	66.3%	
Mar. 23, 2014	4:39AM	10:34AM	54.9%	Third Quarter at 5:46PM

Persistence

Some nights it takes time to get the perfect shot of the aurora. While there are times our workshop group will hang around the cabin and village area because of its convenience, there are times we will head out on the road to one of several spots where there is a good foreground for aurora shots.

DON'T PACK IT IN TOO SOON

One such time, we had an incredible display that seemed to go on all night. Actually, the big breakup lasted about 45 minutes at the new destination—after there was a good 30-minute display around the cabins.

When the action died down this second time, we waited around for about an hour to see if there was going to be another big blast right after solar midnight. Most of the people in the group were getting weary, so we headed back to the cabins. There was still nothing in the sky. As we were getting our gear inside, there were signs directly overhead that something might kick up.

The one hearty soul who decided to set his gear up and go for another round was very glad he did! During the next 20 minutes, a corona formed overhead and the bottom dropped out with some red and deep purples accentuating this incredible breakup.

Several of the participants were kicking themselves the next morning when he told them about what he saw after the others called it a night!

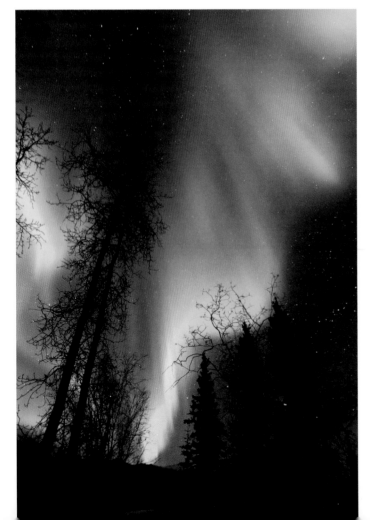

PATIENCE PAYS OFF

On another occasion, I was working with a group of six women from Australia who had traveled to Alaska for their northern lights adventure of a lifetime. They were told about solar midnight and that within 20 minutes or so on either side of this, there is a better than likely chance there would be a good bit of activity.

The first couple of nights several of them called it an early night while others waited for that magical hour and were rewarded for their efforts.

Some nights, it takes persistence to get the perfect shot.

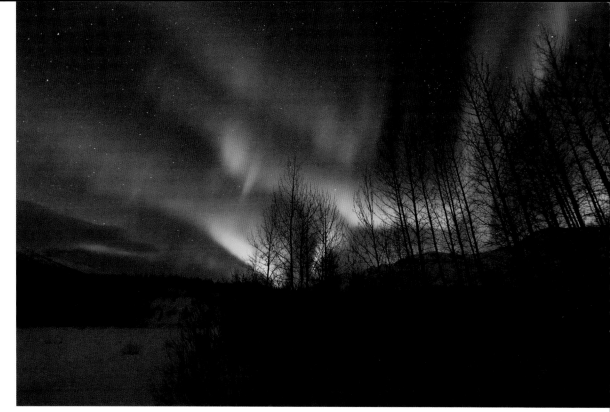

Just like everything in nature, the timing and appearance of the aurora can be unpredictable.

Near the end of the week, everyone finally stayed outside to wait for solar midnight. Just like everything in nature that can be unpredictable, the time for solar midnight came and passed with a blank sky.

They were urged to hang in there but they were getting a little anxious about getting some sleep before a planned drive later that morning. Happily, their patience paid off. There was very good display about 20 minutes after solar midnight. It appeared from an almost blank sky right near the end of the window they were told about. And sometimes the start is even later. Patience!

Shooting Etiquette

When out photographing the aurora with one or more people, there are a few good do's and don'ts you should consider to make the night enjoyable for everyone around. These tips can apply to just about any photography trip.

WATCH WHERE YOU WALK AND SET UP
With numerous people shooting in the same area, it's easy to move around for a different angle and accidentally get in someone's shot. The aurora involves wide angle photography, so the field of view can be pretty broad. While a dark body might be able to be cloned out, bright LCD screens or flashlights are more difficult to eliminate.

As you are moving to a new spot, always take a look behind you to see if you are setting up in front of someone. Even better, call out to ask if you have moved into any-

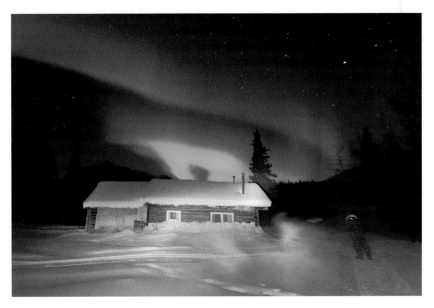

Here's a double whammy: someone walking into the composition and using a red light to look at their camera.

one's field of view. Likewise, if you are on the receiving end of someone getting in the way, call out to alert them that they have moved into your composition.

TURN OFF OR COVER YOUR LCD

Some cameras are designed so that the rear LCD remains illuminated. On some models, a search through the menus can get this turned off; others have it on all the time. It's not noticeable during the day, but at night it is very evident. This can be frustrating for the shooter with the light constantly on in front of them—and for others nearby whose images then include that light reflecting off the snow.

If you can't turn off the LCD, cut out a piece of thin cardboard to a size just a little larger than the LCD area and attach it to the back of the camera. Tape it across the top so the cardboard can be lifted up as needed to see the LCD for image review.

SOMEONE ALREADY THERE

You did some day scouting and found a great spot with wonderful foregrounds and enough space for you and the group you are with to have a good session. When you arrive that night, however, there is another vehicle there.

If it's a large public space, feel free to park off to the side and set up so that you don't interfere with their space. If the area is secluded and they got there first, as much as it hurts, move on to another of your scouted areas. You can go back later to see if they have left—or go there another night.

SMALL FLASHLIGHTS AND HEAD LAMPS

Invariably, you will need to turn on a light at some time during the night to check some settings, find a button, or change a battery. When you do this, either move away from those nearby or ask if anyone is shooting and if it's okay to turn a light on for a moment. Try to be as quick as possible if the aurora is active. If it's during a lull, it's safer to turn a light on.

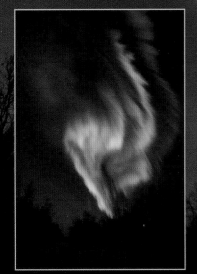

Image Processing

Going from the "before" to the "after"
and employing a few special techniques

Before (small) and after (large)
image processing.

Walking Through the Workflow

The first thing to consider when beginning post-processing work on an image is what it should look like when the work on the file is complete. There is always room for artistic interpretation, but it is best to present your image based on what was seen when it was originally taken.

The camera can only capture so much information; when it is lacking, some work has to be done after the fact. Conversely, with northern lights photography, the camera's high ISO and long exposure can sometimes pick up more than what you perceived in real time.

If you talk to photographers about which programs they use and what steps

THE BASIC STEPS NEEDED FOR MOST AURORA IMAGES

- Lens profile correction/vignette reduction
- Color adjustment (White Balance and Tint)
- Tone curve adjustment (Shadows)
- Levels adjustment (Shadows, Blacks, and Exposure)
- Tonal adjustment (Saturation, Vibrance, and Clarity)
- Sharpening
- Noise reduction

they take to get a photo fixed the way they like it, each one will likely give you a different response. Because of that, it helps to understand some of the basic post-processing principles and steps as they apply to aurora photography. Even after this discussion, you might want to change things up a little bit in terms of the order of the steps and magnitude of the adjustments. That's fine. What's important is that you enjoy the final outcome from what you create with your camera and computer.

The following pages contain examples that show how each step can be achieved in Adobe Camera Raw. Many other programs offer similar settings to achieve the same outcome. Different work can be done based on the conditions, with the primary concern being whether there is a bright moon or a dark sky. The next few pages detail several of the steps in the process, followed by a step-by-step that walks through several images, including the "before" image seen to the left.

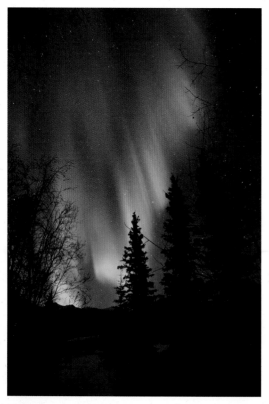

This image can be improved. We'll look at how, later in this chapter.

Repairing Vignetting

One baffling fact about shooting the aurora with expensive, full-frame camera equipment it that vignetting occurs in the corners with some wide-angle lenses. This happens with the Canon 16–35mm L series lens on whichever full frame body is used—usually at the 16mm end and at f/2.8. On some images this is not noticeable, but on ones with snow on the ground (or a very active aurora on the top) it can be highly evident.

Luckily, this can be corrected in post-processing, if it's even bad enough to need correction. In both Adobe Camera Raw and Adobe

Lightroom, the feature for fixing this is in the Lens Corrections panel. The programs can fix both this and any other lens distortions automatically, or you can adjust them manually.

In the "before" image below, look at the corners. Compare them to the "after" image. Quite a change. This was done using the auto fix in Camera Raw.

The "after" image (below) shows more detail in the trees on the bottom (both on the left and right corners), more aurora at the top right of the frame, and a few more stars in the top left corner.

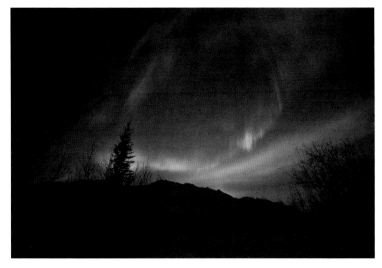

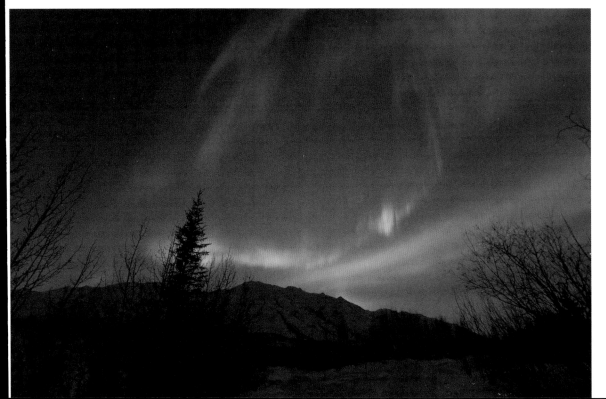

White Balance

These examples show how the color and appearance of a night sky image and the aurora are affected by adjusting the white balance setting.

Applying the Cloudy setting (6500K) gives the sky and the aurora a warmer cast that is not fully natural for this subject. The Custom setting (4500K) cools the image down a bit too much; it makes the blues bluer and makes the green of the aurora too bright. The As Shot setting could be considered the most accurate. However, some people may prefer the more neutral sky the Auto setting chose for this image, using a color temperature of 5950K—not much higher than the As Shot of 5400K. Depending on the conditions, the Auto function will give a different temperature setting.

For these images, no other processing work was implemented, so the result of changing the white balance to different presets would not be skewed.

The 5400K ("As Shot") image in this example sequence is the camera's equivalent to the Daylight setting in Camera Raw (5500K). Different camera makers have a slight variance in temperatures for the different presets. When doing the adjustments, a change of 100 degrees here and there does very little to the image.

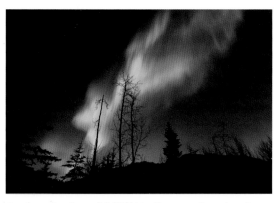

As shot. Setting of 5400K in Camera Raw (equivalent of daylight [5500K]).

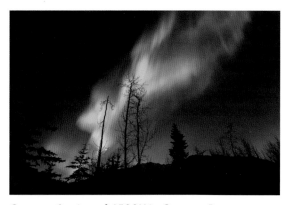

Custom. Setting of 4500K in Camera Raw.

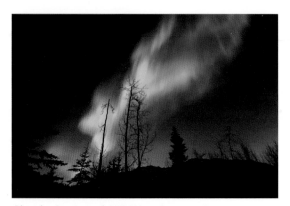

Cloudy. Setting of 6500K in Camera Raw.

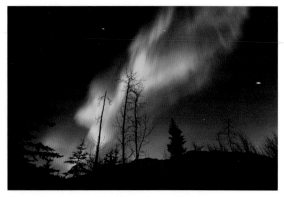

Auto. Setting of 5950K in Camera Raw.

STRIVE FOR SUBTLETY

While it is best to get the exposure correct in the camera when taking each image, there will be times when changes to the exposure in Camera Raw or Lightroom are needed. No matter what part of the image needs exposure adjustments (the aurora or something else), make sure that the final presentation does not make the image appear as though it has been altered.

INCREASING THE EXPOSURE

Frequently, an aurora image might be a bit too dark. When adjusting the histogram to the right from the left side (making pixels lighter), keep in mind that more noise may become visible. While this can be accounted for (see pages 102–3), it's best not to increase the exposure too much.

There are times, however, when a fairly substantial increase is necessary—such as when some colors that showed up in the camera (but not to the eye) need a bit of a boost or the overall image is too dark.

One option is to lighten the Shadows in the Tonal Curve panel. When an exposure increase is made, it's also good to use the Blacks slider to help balance out the sky and make it a little darker; you do not want those areas that actually were very dark to become too bright.

Looking at the two images to the right, you can see that the exposure of ISO 1600 at 15 seconds was not enough (top). However, I wanted to save this image because of the reds and yellows in the aurora.

The bottom image incorporated an Exposure increase of +1.5; the Blacks were

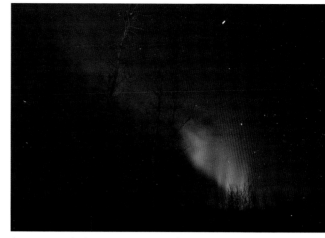

As captured, the image was underexposed.

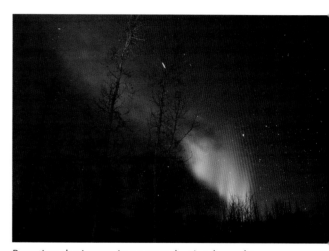

Boosting the image in postproduction brought out the trees and the red/yellow colors in the aurora itself.

left at the preset of 5. I decided to leave the Blacks unchanged because increasing the slider even by 1 caused the trees to be lost against the sky.

The increase in exposure not only made the aurora brighter but it also brought out more stars in the sky, especially in the bottom right section.

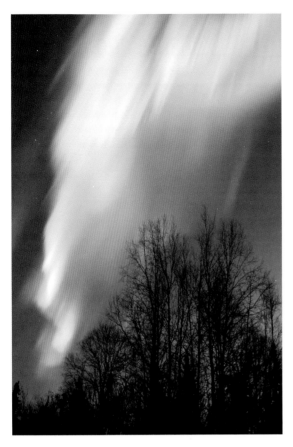

ABOVE—The initial capture (left) was overexposed. I toned down the exposure (right) and boosted the Blacks.

RIGHT—While there are still a lot of pixels shown on the shadow side of the histogram, there is an even amount on the right half and a nice tone in the aurora.

DECREASING THE EXPOSURE

There are times when a portion of the aurora gets brighter than you expected during the time the shutter is open. Fixing that means decreasing the exposure.

Even though the top left image was shot at just 4 seconds at ISO 2500, it was a bit too bright and lacked definition in numerous places. When the aurora is dancing, the exposure levels can change quickly. In this case, it became quite a bit brighter than in the preceding shots.

To help tone down the bright areas, the Exposure slider was set to –1. If I had originally shot the image at 2 seconds, this is what the detail and brightness of the aurora would have looked like. Besides toning down the bright spots, it also provided more detail in the curtain.

To help the sky, the Blacks were set to +15—higher than the typical setting (10 to 12). This helped diminish the city light pollution on the right side and darken the sky to the left of the aurora.

Shadows

In the Tone Curve panel, the tool that will get more use than any other is the Shadows slider, which controls a lot of the shadow areas, but not the very darkest blacks. That makes it an incredibly useful tool for bringing out hidden details in the shadow areas.

I also use it quite often on aurora images to help reduce the need to change the Exposure slider, which has more of an effect on all the pixels in the image (as opposed to just those in the shadows).

Dragging the Shadows slider to the right opens up everything in the shadows. Dragging this slider to the left darkens the shadow area—but using the Blacks slider to darken the shadow areas and the sky does a better job for this function.

Before (right) and after (below) adjusting the Shadows slider.

The Shadows slider is helpful for bringing out detail in snowy foregrounds and lightening up the aurora a little (unlike the Exposure or Fill Light sliders, which cause changes to the whole composition). Below, notice how the snow becomes a bit more apparent. The sky around the aurora is not quite as dark but the colors are close to the same in both, showing that only the midtones were affected by the Shadows slider.

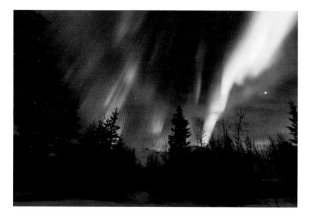

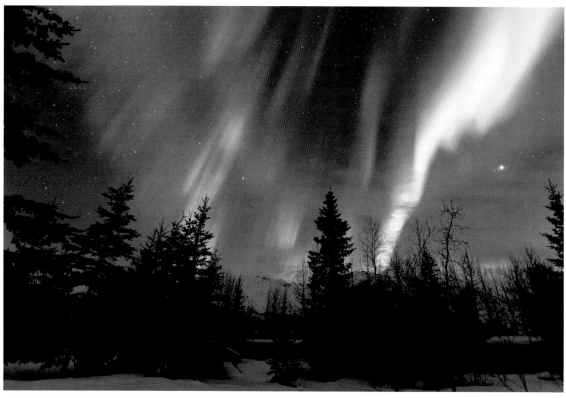

Saturation

One area of Camera Raw that can often come in handy is at the bottom of the Basic panel: the three sliders for Clarity, Vibrance, and Saturation. The Saturation slider helps bring out the colors more than the other two, but they will all be used in most cases where the color intensity needs a boost.

Looking at the images below, the top photo shows how the file appeared with no adjustments. For the bottom image, I used a Blacks adjustment of +12 (from the preset of 5) to help darken the sky a little bit. Although the Saturation slider is the last one on the menu, this is the first one I use to

help bring out the colors in the photo, followed by the Vibrance and then the Clarity.

To help bring out the purples within the band on the left, the Saturation was increased to +14 (within the range of +15 to which I limit my adjustments). My goal was to bring out the purples without making the greens in the right auroral band look too bright, so I moved the slider until the greens *were* too bright and eased it back down until they looked good. Likewise, I adjusted the Vibrance slider until it was too much and then backed it down to +13. The Clarity was increased until there was a little more detail in the bands above the mountain (to +8).

The Blacks slider also darkened the snow a little bit but this can be taken care of with other settings, primarily the Shadows slider in the Tonal Curves.

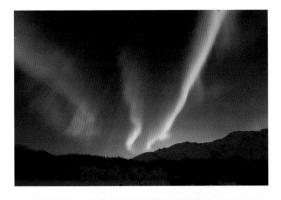

Before (left) and after (below) adjusting the Saturation, Vibrance, Clarity, and Blacks sliders.

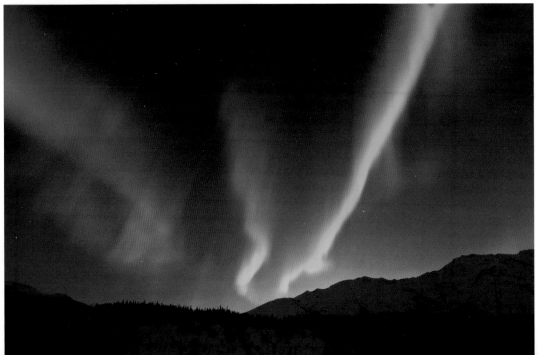

Sharpening

Because a pre-focus is set on the camera before shooting, most everything in your aurora images should be pretty sharp. However, a little bit of sharpening still typically needs to be done due to the nature of shooting in RAW mode. As with any workflow, sharpening should be done *before* reducing the noise, since sharpening in and of itself adds some noise to a night sky.

Do not use the aurora itself as a guide for determining when the image is sharp; the aurora will have soft sides, even when there is a distinct curtain pattern. Instead, look at the foreground, whether it be some trees, a mountain ridge, or a building.

When you are doing fine detail work (like sharpening) on a file, be sure to enlarge the image size to a 100 percent view and pick an area that has a good bit of detail. For this image, the trees in the aurora were used because there was plenty of contrast and detail in that area.

When sharpening an aurora image, I increase the Amount until noise starts appearing. Increasing Radius and Detail is a personal preference; I usually

leave Radius at the preset of 1. If there is a lot of detail, I'll bring that slider up until the increased noise becomes apparent.

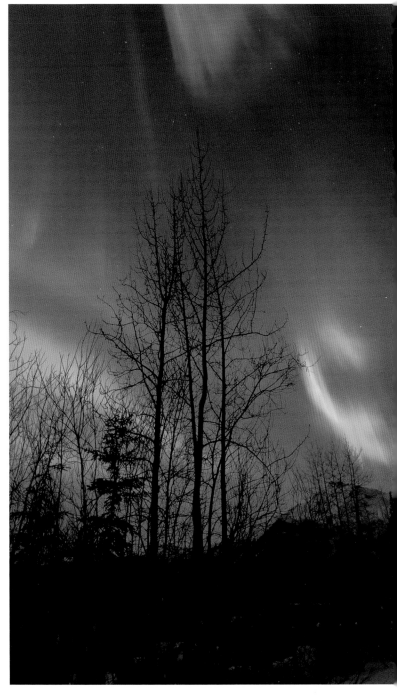

I used the following settings to sharpen this image: Amount 63, Radius 1.0, Detail 32.

Noise Reduction

Back in part 2, we looked at the noise reduction options you can set when getting your camera ready. No matter which of these you use, though, there will still be some noise in the photo. Depending on the camera settings and how many megapixels the camera's sensor records, there could be quite a bit of noise. Happily, there are post-processing tools to help offset this.

The noise reduction features in both Camera Raw and Lightroom, will help take away—if not eliminate—noise created due to the use of long exposures and/or high ISO settings. In my experience, it is something you will want to use on every aurora image you process. (*Note:* Besides these two programs, plug-ins from Noise Ninja and Nik also work well for noise reduction.)

In Camera Raw, the noise reduction features are found in the Detail section, which conveniently contains both the sharpening and the noise reduction tools. In Lightroom, look for the Detail panel in the Develop module.

It is important to apply any needed sharpening *before* addressing the issue of noise reduction. Then, with the image at 100 percent view, drag the Luminance slider until the noise disappears and back it down a little bit. Adjust the Detail slider to your preference. This is where things get a little touchy; using too much Luminance or Detail has a tendency to interfere with the sharpening done previously.

It's worth seeing how far the Detail slider can be pushed to decrease the noise. If there's any color noise, dial up the Color slider until that disappears. We're trying to avoid two things: too much noise in the pixels (some is okay, as long as it is not

Side-by-side comparison in Photoshop of part of an image, enlarged to accentuate the before (left) and after (right) of adjusting Luminance in Camera Raw.

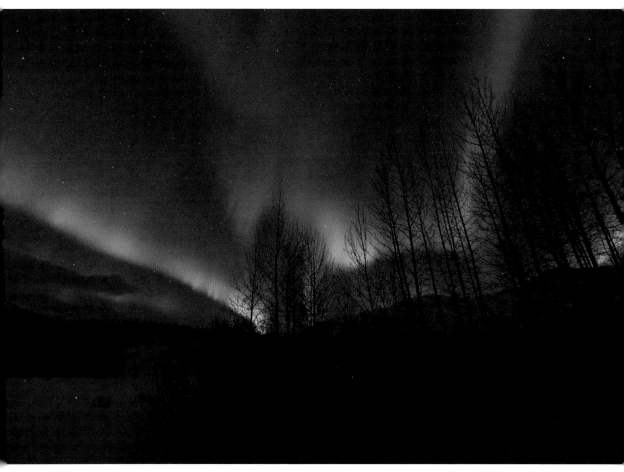

The full image with the only adjustment done being to Luminance. There was no Sharpening, White Balance, Saturation, or Exposure adjustments made.

color noise) and excessive sharpening to the point where there are visible halos at the edges of the subjects, especially in the foreground.

Luminance noise reduction can dramatically reduce the level of detail and perceived sharpness within the image. Color noise reduction may also introduce saturation issues, color blending, and other problems related to the color values within the image.

Noise reduction is best applied to the minimum extent necessary to get acceptable results. Try to avoid going much over 70 with the Luminance slider, as that is where critical sharpness tends to get lost.

SAVE YOUR SETTINGS

Once the noise reduction Detail settings for any given camera and ISO value have been determined, save them by picking Save Settings (in the tab name bar), select "Detail" as a subset, then save the setting under a name like 5DIII_ISO2500. The next time you need to convert a file from this camera and ISO setting, go to Load Settings and it should look good. Even with saved settings like this, however, it's best to do a 100 percent view evaluation to double-check your results.

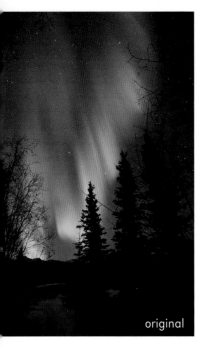

original

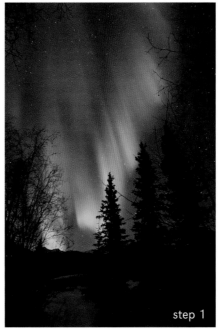

step 1

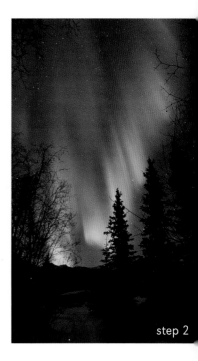

step 2

Image Processing Steps (No Moon)

ORIGINAL

The first image in this sequence shows the RAW file with no processing work done.

STEP 1

The vignetting can be adjusted manually or the program can do it automatically in the Lens Corrections panel. In this case, I used the auto adjustment.

STEP 2

I tried various white balances. I looked at As Shot (5800K) and Auto (4800K), then picked an in-between value of 5300K. I upped the Tint slider to +29 to accentuate the purples.

STEP 3

The image was originally shot at ISO 500 but could have been a bit higher. I com-

pensated by increasing Exposure by +.75 and the Blacks to +7 to help the sky. In the Tone Curve, I increased the Highlights to +5 and the Shadows +7 to help the snow.

STEP 4

I adjusted the Saturation to +100 and then backed it down to an acceptable level. I did this for all the settings. It's good to use a little higher setting for night shots than day photos. I ended up with: Saturation +20, Vibrance +15, and Clarity +10.

STEP 5

I increased the image view to 100 percent and boosted the sharpening until the foreground was crisp. I set the Sharpening to 56 and increased the Detail to just before the noise increased (45). For noise reduction, I boosted the Luminance up to

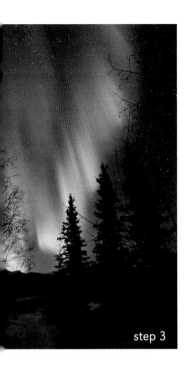

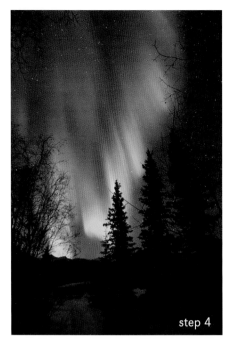

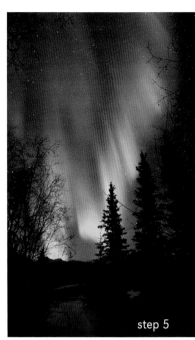

step 3

step 4

step 5

smooth the shot, and backed off a little bit to 70. I set the Color slider to 40.

FINAL

I made my final adjustments in Photoshop, removing the red light next to a tree and cloning snow off the roof of the cabin. If there had been dust spots on the image, they would have been cloned out at this point, too.

Comparing the before and after images, it is obvious that everything was already there in the original—it just needed to be brought out with a bit of adjustment. I would have done the aurora a bit dimmer to use this image another context; here, I wanted to show how much is possible.

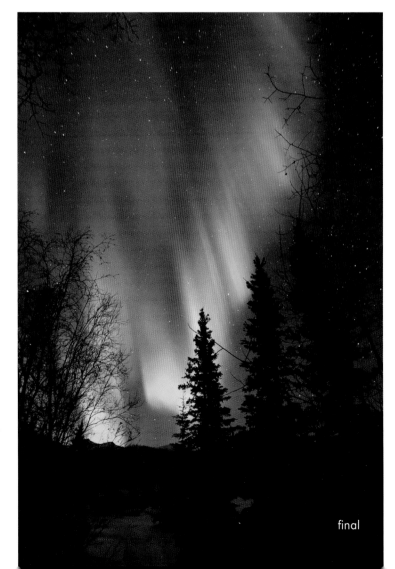

final

Image Processing Steps (Moon) _____

ORIGINAL

This is the RAW file with no processing. The steps for this image will be a bit different because of the moon and some clutter in the foreground. The position of the aurora changed from overhead and north to the south. When the composition is not ideal, shooting can still be done.

STEP ONE

I cropped the image in Camera Raw. This is accomplished by selecting the Crop tool,

and then clicking and dragging on the edge/corner handles of the crop indicator to adjust the aspect ratio and remove any image areas you want to exclude from the composition.

Right after doing the crop, I went to the Lens Corrections panel and checked the box for automatic lens-distortion and vignette repair.

STEP TWO

I used the auto white balance setting to take the image; after several tests with some slight changes, it seemed best to keep this the setting and move on to the next step: changing the exposure. I switched my usual order and did the Blacks first, increasing the slider to 9 to make the sky richer while maintaining the blue from the moon. I used the Exposure to bring out the purples by adding +.25. In the Tone Curve panel, I found that the only slider needing any change was the Shadows to +5. This slightly improved the separation of the aurora from the sky.

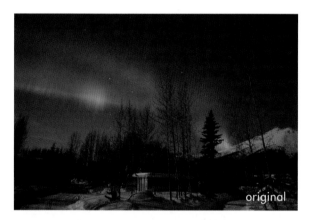

original

STEP THREE

In the Basics panel, I moved the Clarity slider all the way to +100 to see what effect it had; I liked the change in the detail on the mountain, so I moved it back down just until some started to be lost at +40. This was much higher than the maximum of +25 I try to use. I knew I wanted the purples more saturated, so I used the arrow key to increase it a step at a time until the greens started to get too bright (+18). I moved the Vibrance slider to the right until it was

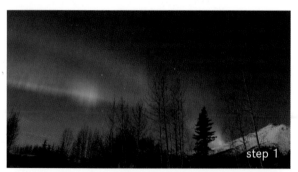

step 1

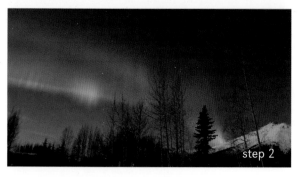

step 2

too much and then backed it down until it looked nice and the bright green spot on the left side was acceptable (+12). To accentuate the purples a bit, I went to the HSL panel and adjusted the purples to Saturation +30 and Luminance +10.

STEP FOUR

The file was able to handle a good bit of sharpening before any banding or noise was introduced. I set it to: Amount 80 and Detail 50. In the Noise Reduction section, I slid Luminance up to 70 and worked it back down to 60. The Color slider needed very little adjustment, moving up from its original setting of 25 to just 30.

FINAL

I finished the image in Photoshop, using the Spot Healing Brush tool to remove a dust spot in the cloud on the lower left and the Clone tool to eliminate the top of a sign and a snow-covered roof from the bottom edge of the frame.

To review, the main changes to this image were cropping off the bottom, bringing out the blue sky caused by the moon, and popping the purples a bit. In the final image, the snow is still a good white and there is even a bit more detail on the side of the mountain from bumping up the Clarity.

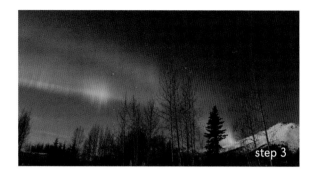

step 3

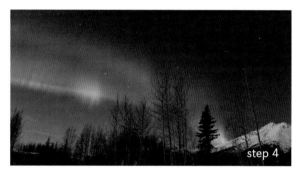

step 4

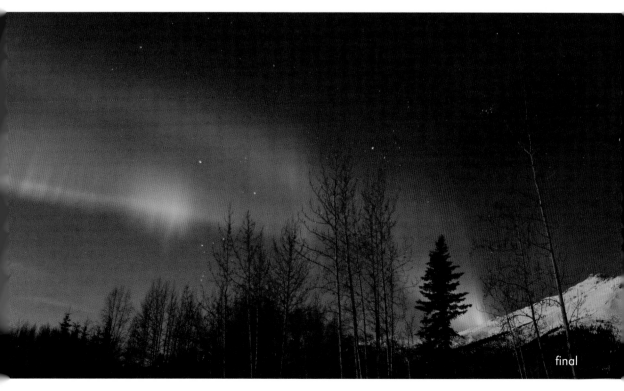

final

Preparing a Finished Product _____

The final steps in post-processing work are dependent on the planned usage. Is the plan to share the image online with friends and family? Is it the intent to create a presentation for display on a television, computer, or LCD display? Or is it to make a print to hang on a wall?

For each of these end uses, there are some final steps to get the file prepared in just the right way. While there is some overlap, there are some differences in the process for each output.

GENERAL

If there's any chance the image may be used for another purpose in the future, start by archiving it at the size the file was when imported into Photoshop and in a lossless format. The most common of these formats are TIFF, PNG, and PSD. This way, there is a full-sized, final product file from which image files in multiple sizes and formats can later be created. Avoid saving a JPEG twice; re-compressing the data causes file degradation. It's fine to keep one final JPEG file.

ONLINE

For online use, the image should be the smallest file size possible. This helps protect against people trying to save it for other purposes. It will look fine on another web page but not as a screen saver or to make a print from. Using 72ppi is good, as this is what most computer screens present. Set the color space to sRGB and the file will match the computer output. For the long side of the image, set the size to between 600 and 1200 pixels.

How the file is sharpened for the web matters both for visual impact and for transfer speed. Use an all-over sharpening and then use selective sharpening of the important elements. This will give the impression of sharpness. Review the image at a 100 percent view after resizing; this matches how the image will be displayed online.

Photoshop has a Save For Web control, which enables the testing of various modes and saving parameters, showing the file size and final appearance. Some pictures need higher quality to avoid artifacts in areas like the sky. Other pictures look just the same at quality 3 as they do at 12—and take much less storage.

PROJECTION

Different projectors (depending on how old or new) call for different image sizes. Below are the best file sizes based on the type of projector. All work with the sRGB color space. Again, do the final sharpening and review at 100 percent. Set the resolution (ppi) to 94 for these larger displays.

- For new high-resolution digital projectors, images should be 1920 wide by 1200 pixels high.
- For XGA size projectors, limit the width to 1024 pixels by 768 pixels high.
- For older SXGA size projectors, limit the width to 1400 and the height to 1050 pixels.
- For the new WUXGA projectors, limit width to 1920 pixels and the height to 1200 pixels.

- For full HDTV, limit the width to 1920 pixels and the height to 1080 pixels. Convert your colors to the HDTV color space for television display.

PRINT

When creating a file for a photographic print, it should be saved in Adobe RGB, which has a larger color gamut than sRGB. Working in the 16-bit space and with TIFF as the file format also provides more robust control than JPEG—especially when doing a lot of image manipulation. This translates to better color, sharper details, and smoother tonality for the final product.

There are three primary steps to preparing a photo for printing. An important first step is to calibrate the monitor. Most screens have a strong color cast; without calibration, your prints won't match the display. Calibration is easy with a device such as those made by Spyder.

Second, adjust the brightness of the image. Monitors tend to be overly bright for printing. Start by reducing the brightness of the monitor to around 50 percent, then brighten the image. It will seem strange at first, but the photos can come out too dark if this isn't done.

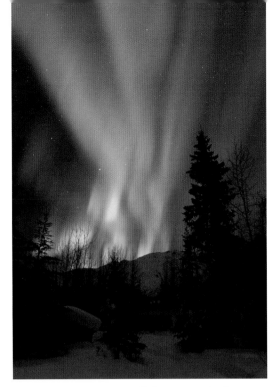

The intended end use will determine the best way to prepare your image file.

Finally, the image needs to be sharpened. Personal preference dictates the selection of sharpening approaches. Trial and error will also reveal that the amount of sharpening needed varies according to the subject matter, paper surface, and print size.

Create a file for each size of print being made, starting with the largest. For home-based printing, saving a final JPEG file will make the job go more quickly.

Creating a Time-Lapse Image

Capturing real-time video of the aurora has long presented a challenge for digital photographers. For those who want to record motion, time-lapse photography is a popular and pleasing solution—and will likely remain so even as technical advances make capturing real-time video more feasible (as with the results we're now seeing from the Sony A7S).

ONE CAVEAT

While time-lapse sequences are an interesting thing to capture, this shouldn't consume a lot of your shooting time. The

positions and directions of the aurora usually require constant camera repositioning to get the best action—and the exposure changes when the aurora gets intense can lead to segments where the activity is blown out.

If a second camera setup is available, it could be a good thing to let it run all night (or until the battery dies) after the night's shooting is done. Another option is to have it set up near the main camera; when a good burst is going on, start it and let it go for a certain amount of time.

HOW TO SHOOT

For shooting the aurora, the typical settings for getting a high-quality still shot with a nominal camera body are ISO 800 and a shutter speed around 10 seconds. For doing a time-lapse sequence, the ISO should be bumped up. Newer cameras operate at very high ISOs without producing a lot of noise; on these, the ISO can be set at 3200. For a star trail image (see next section), set the shutter speed at 15 seconds; to concentrate on the aurora, using a shutter speed of 5 seconds won't give you as many stars filling the frame.

Set the drive mode to continuous and attach a cable release. While the cable release is locked in, shot after shot will then be taken.

The steps for creating a time lapse of the aurora can be applied to other active subjects, too. If the subject doesn't require long exposures, just lower the ISO and use faster shutter speeds.

POST-PROCESSING

After the images have been taken, the work begins in post processing. First, convert all images from RAW to JPEG. A good PC viewing and converting program for this is BreezeBrowser.

Next, resize all of the images to a moderate size of 180ppi and a width of 1070 pixels. There are a variety of ways to go about doing a batch resize for this. A free utility for this is Multiple Image Resizer. This program has several features, but for this project all that's required is selecting the folder with the images and choosing the resize option to scale the width. Type in the desired size, select the save option, and hit go.

For creating the movie, Windows Live Movie Maker is a free, easy to use program that can put everything together. In Movie Maker, select the files to be included in the movie. Once they are loaded, go to Select > All and hit Edit. Set the duration each image is shown to a time of 0.2 seconds. On the Home tab, there are several options for saving.

On the Mac, iMovie is where a time lapse can be created. Import the images into a new project and use the desired settings. Go to Select > All, then choose the Crop tool. Use Fit to turn off the Ken Burns effect (the image zooming in and out during the time it is up). When hovering over any of the images, three icons appear on the left side of the frame. To set the duration of each image in the final movie, click on the Preference tool at the bottom and select Clip Adjustments. You can also click on the Inspector icon on the tool bar in the middle of the screen to reach this.

View the movie and enjoy.

Creating Star Trails with the Aurora

Picture two different scenarios. In one, the aurora has not appeared—not even the wisp of a homogeneous band. In the second, a night of shooting the aurora seems to be over; it's close to 3AM and the activity has been quiet for close to an hour. If you are in a safe place where the camera can be left set up outside for the remainder of the night (until the battery dies or a card gets filled), then the shooting does not have to come to an end.

With the ability of camera bodies to shoot at high ISOs, creating star trails (with the chance of the aurora coming into view during a sequence of shots) is worth the effort. Until recently, star trails images had to be created using the camera's bulb setting with a cable release and an exposure of 30 minutes or longer. That has changed. Today, there are programs that allow photographers to capture a series of individual shots and stack them together in postpro-

BELOW AND NEXT TWO PAGES—The three images in this section were all taken from the same sequence of captures, showing that a variety of very different results can be pulled from a single series of shots. It's also possible to just pull out one shot for a nice aurora capture instead of a star trails stack. The component images were taken on a night when the aurora did not appear during our planned shooting time. At about 1:30AM, several people set a camera up outside of our cabin in northern Alaska to take a stacked star trails shot—knowing that if the aurora did appear later in the night, it would be a bonus. The full set of images totaled 417, exposed at 15 seconds each.

STACK 1—This compilation was made from 198 images stacked together using StarStaX. When doing setups like this, it's possible to pull individual shots where the action is good. Because the intensity of the aurora varies at different times, a 15-second exposure can be too much or too little; there is a chance of having several overexposed shots in the sequence that can cause problems for doing a full stack. If there is a favorite sequence with one or two overexposed images in it, these can be eliminated from the final output.

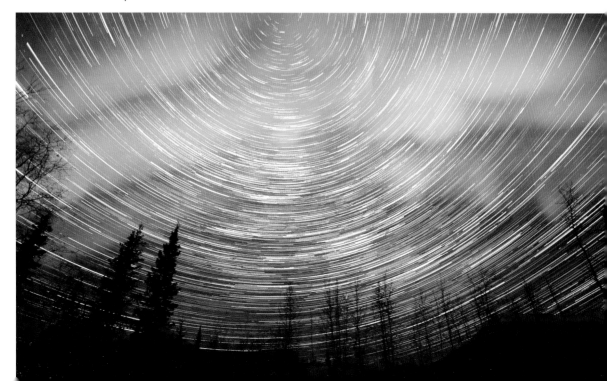

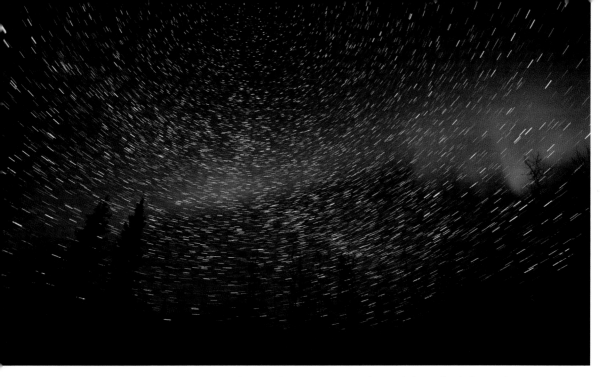

STACK 2—This image was created from a short portion (21 frames) from the full set of 15-second exposures. This let a slight tinge of red appear along the top right edge of the aurora. This section of shots was also during a time when there was very little definition to the band, putting more emphasis on the short star trails.

duction to create a single, high-quality photograph.

To create a star trails shot, with the chance of the aurora appearing in it, find a location to set up the camera with a good foreground and a portion of the sky where the aurora might appear. Set the ISO at 1600 and the shutter speed for 15-second exposures. Set the motor drive to continuous high and lock the cable release so the shots will be taken one after another. To maximize the number of frames that will be taken during the remainder of the night, it's a good idea to put a fresh CF or SD card and new battery in the camera before starting the series of shots.

In the morning, it's important to transition the camera and lens from the cold to the warmth, as discussed previously; they will be colder when left out for the duration of the night. Also, take the battery out and charge it during the day so it will be ready for the next night's shooting.

The group of individual shots can then be post-processed to stack the images together. There are a variety of programs and options for accomplishing this. Besides using Photoshop, one option is StarStaX (www.markus-enzweiler.de/software/software. html), a free program that works on both Mac and PC platforms. Startrails (www. startrails.de/html/software.html) is another free program but only works on the PC. A third option is Image Stacker (www.tawbaware. com/imgstack.htm). From testing each option, StarStaX seems to do the best job.

CONVERT THE FILES TO JPEG

The one drawback is that most of these programs only work with JPEG files. On a

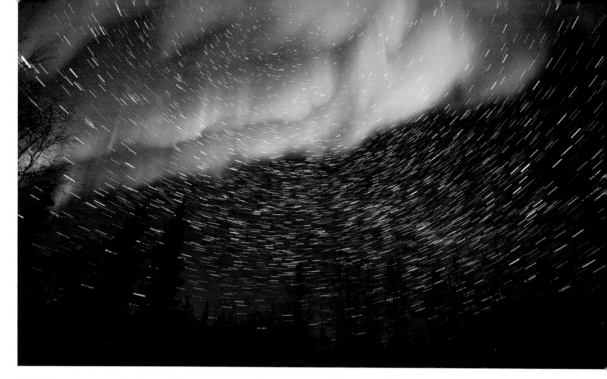

STACK 3—A small selection of images can result in more definition in the separate bands that appear. Here, using 39 exposures provided a bit of definition within the aurora bands, even showing a bit of the curtain in the lower two sections on the left side.

PC, a great program for batch conversion is BreezeBrowser. Digital Photo Pro, a Canon utility program, allows for both converting and resizing to be done at once, should you wish to work with smaller files for the stacking process. Other options can be found in Bridge and Lightroom.

STARSTAX QUICK OVERVIEW

Once the StarStaX program is open, there are three Preference tabs: Blending, Images, and General. Under Images, the Smooth option is better than Fast or Automatic.

In the Blending tab, the options include Lighten, Gap Filling, Darken, Add, Subtract, Multiply, and Average. Here, Lighten or Gap Filling work best. If Gap Filling is used, a button appears to access a Tools section where the Threshold, Amount of Gap Filling, and Brightness can be adjusted.

Adjusting the Threshold slightly to the Low side and the Amount slightly to the More side works best to fill in any gaps that might have occurred between clicks of the shutter. When viewing on the computer, there is very little visible difference between Lighten or Gap Filling using the Smooth setting. However, Gap Filling does a little better job for making a print.

Even though lots of single shots may be taken, not all of them have to be used for the final image. However, those that are used do need to be sequential so that gaps don't appear in the trails. The images in this section show what can be accomplished with this technique using varying numbers of shots. StarStaX was used for compiling each of the final stacked images.

Bringing Out the Milky Way _____

What better element to compliment the aurora borealis than the Milky Way? These are the two phenomena in the sky that draw more attention than any others. The Milky Way is visible in different parts of the sky at different times of the year, depending on the location. It does take a dark sky to be visible to the eye, so areas with lots of light pollution can obscure the Milky Way.

SHOOTING

When both the Milky Way and aurora are visible, there are some settings that need to be used to put everything together.

Star photography of the Milky Way is best handled with a very high ISO. My preference is between 2500 and 4500, with 3200 being used quite a bit. Shutter speeds of around 20 seconds are also best for getting more stars, as well as the depth of the Milky Way.

Depending on the brightness of the aurora, this might be too much exposure; this combination of ISO and shutter speed is best used when the Milky Way is visible and the aurora is in the general direction of it and not overly bright.

POST-PROCESSING

Post-processing is where the remainder of the work comes. The image below was one of a large series for a star trails stack. The following steps were made to create the finished image to the right. I began with some basic adjustments in Camera Raw, then finished in Photoshop.

1. In the Lens Correction panel, I selected Enable Lens Profile Corrections.
2. In the Basic panel, the following settings were selected: Exposure +1.15, Blacks 8, Clarity +13, Vibrance +1, and Saturation +7.
3. In the Tone Curve panel, I set the Highlights to +10 and the Lights to +10 to bring out the stars.

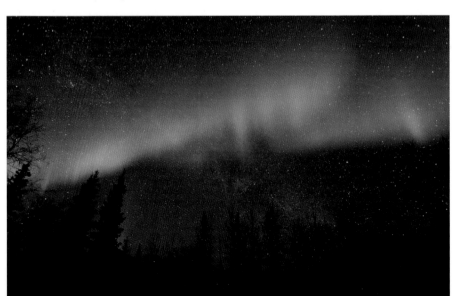

Original capture, converted from RAW to JPEG.

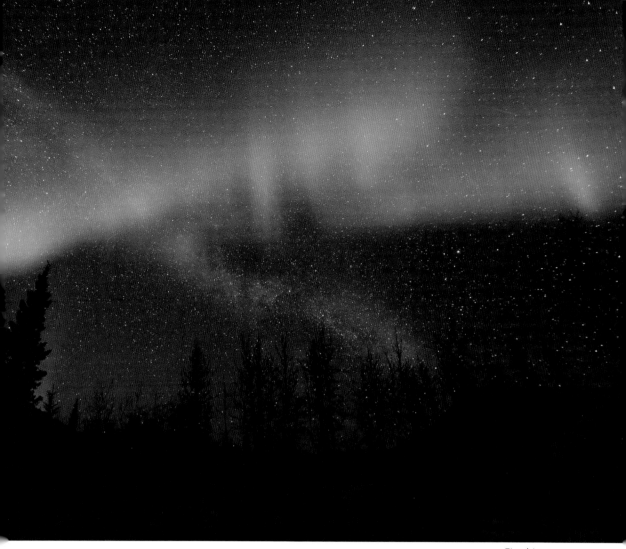

Final image.

4. In the Detail panel, I increased the image size to 100 percent to work with the noise and adjusted the Luminance to 58. After dropping the image size back to Fit in View, I worked with the Sharpening sliders. I found I liked the Amount at 73 and the Detail at 49.

5. I clicked Open Image, so the updated file would be opened in Photoshop.

6. In Photoshop, the only processing work done was with the Dodge tool. An Exposure of 25 percent was used to paint over areas of the Milky Way to bring out the brightness to what it should be. Be subtle here so it isn't made too bright.

When using the Dodge Tool over the Milky Way, only parts that have data embedded in the image are brought out. It will not pull any brightness that was not there—so what is shown in the final image is what was there in the sky. Because of using a high ISO and a long shutter speed, more color and stars are captured than what the eye could see.

Single Shot HDR _____

When taking photos of the aurora, it is not always possible to get the exposure just right for both the aurora and the foreground. However, taking two or three images to use as a traditional HDR composite would result in the movement of the aurora becoming extremely blurred. Any detail would be lost.

In these cases, it is possible to process a single RAW picture as an HDR by making two or three copies of the RAW file—depending on the amount of exposure differences there are in the image. The adjustments can be made in Camera Raw or Lightroom, using the exposure controls discussed earlier.

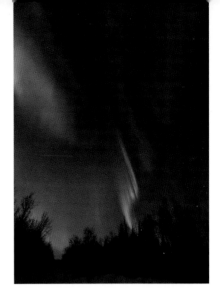

The original image (right) and final image (facing page).

THREE VERSIONS OF ONE FILE

The first version of the image that will be used is the standard one, where the exposure is left alone. In this case, the Saturation levels were set to the desired level and the file was saved as a TIFF.

A second version of the image was processed for overexposure. I increased the exposure by 1 stop to bring out the detail in the snow. A third version of the image was processed for underexposure. I lowered the exposure by 1 stop to help darken the sky around the aurora. The same amount of noise reduction/luminance (+70) was applied to each version of the image.

POST-PROCESSING

After each RAW file has been adjusted, an HDR program such as Photomatix or the Merge to HDR feature in Photoshop can be used to put together the final image. In the resulting image on the facing page, notice the pop in the aurora color and white of the snow.

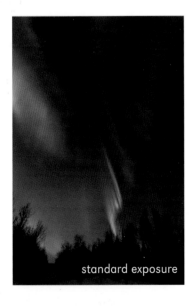

standard exposure

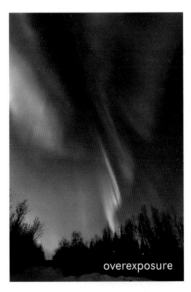

overexposure

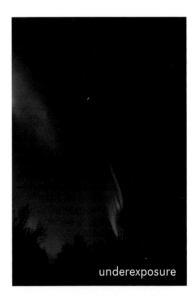

underexposure

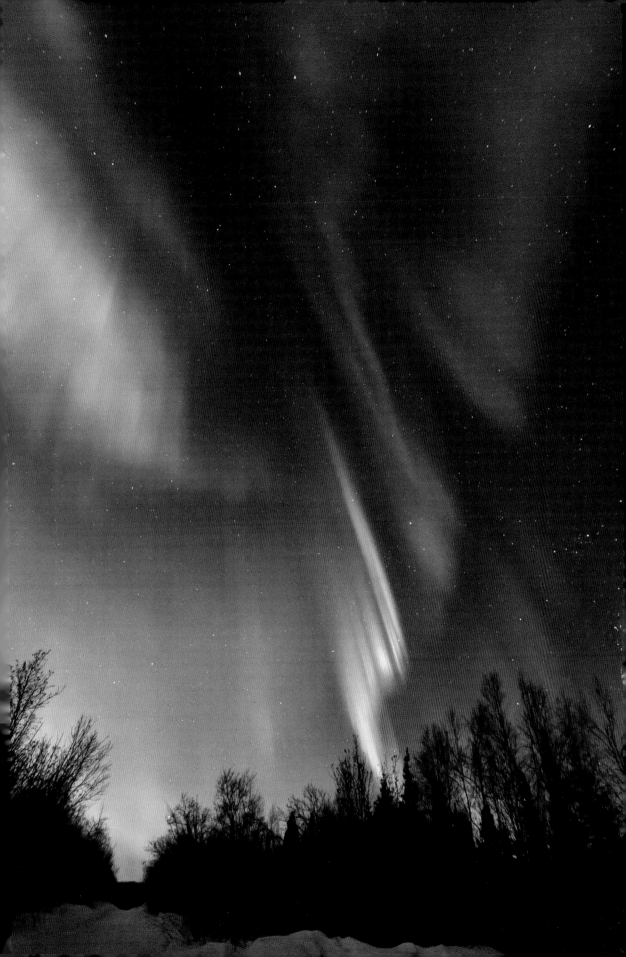

Revealing Camera Problems

There are times when night photography, and aurora photography in particular, might expose a problem with a camera. This was the case with my first aurora shoot. There had been no problem with day photography up to that point, but every image I took at night with long exposures had a line going all the way across it.

HARDWARE REPAIR

After spotting this, I sent the camera body to Canon for repair services and they replaced the defective sensor. This was in the early days of digital, and it was discovered that one batch of bodies had a defective area on the sensors that caused this problem—so the likelihood of this happening today is rare, but it is worth taking a look at your long exposure images to make sure something like this doesn't occur.

ALL IS NOT LOST

What if you get home and see a line like this on a lot of shots? All is not totally lost. As the next picture shows, the line can be eliminated easily one of two ways.

The first is to use the Clone Stamp tool in Photoshop. Increase the view of the image to at least 100 percent to improve the accuracy of the work. Because this is a very small line and there is not a lot of room for error, make the Clone Stamp tool very small by using the bracket key to change the brush size. Pick an area just above or below the line to clone and then draw across the defective area.

The second way to do a repair is with Fill > Content Aware. This is a great tool to

Every image I took at night with long exposures had a line going all the way across it. This image is zoomed to 100 percent to show it clearly.

Using the Clone Stamp tool, I was able to repair the image files created before the camera was repaired.

help get rid of lots of things in images that are out of place. Either use the Rectangle or Lasso tool and outline the problem area then right click inside the selected area and choose Fill > Content Aware or select this under the Edit Menu. The line is gone.

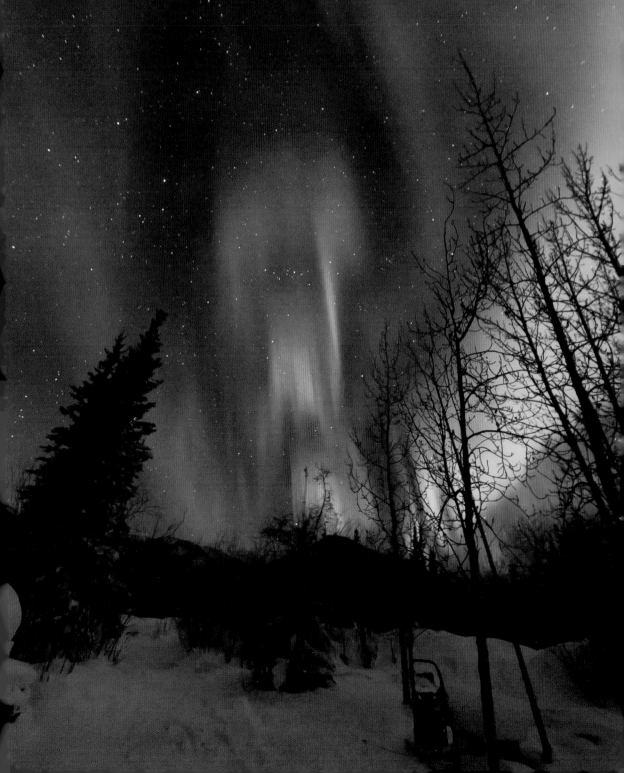

Additional Resources

References and Resources

CLOTHING

Sorel boots—www.sorel.com

LaCrosse boots—www.lacrossefootwear.com

AURORA FORECAST

University of Alaska Fairbanks—www.gi.alaska.edu/AuroraForecast

NOAA OVATION Aurora—www.swpc.noaa.gov/products/aurora-30-minute-forecast

Yellowknife, Canada—www.astronomynorth.com/aurora-forecast/

Aurora Sentry—www.aurorasentry.com

AURORA WEB SITES

Space Weather—www.spaceweather.com

Aurora Alarm—www.auroraalarm.net/

SOHO (Solar and Heliospheric Observatory)—sohowww.nascom.nasa.gov/

Space Weather Live—www.spaceweatherlive.com/en/

SMARTPHONE APPS

Geophysical Institute Aurora Forecast—www.gi.alaska.edu/AuroraForecast/MobilePages

Aurora Forecast (TINAC)—itunes.apple.com/app/aurora-forecast/id539875792

Auroral Forecast (Appex Web AS)—itunes.apple.com/us/app/auroral-forecast/id539414185?mt=8

Aurora Buddy—play.google.com/store/apps/details?id=com.combatdave.aurorabuddy&hl=en

3D Sun—www.nasa.gov/topics/solarsystem/features/iphone-sun.html

DOFMaster (iPhone)—www.dofmaster.com/iphone.html

DOFMaster (Android)—www.dofmaster.com/android.html

MoonPhase (RomanDuck Software)—itunes.apple.com/us/app/moonphase-moon-info/id287526650

PHOTOGRAPHY WORKSHOPS

First Light Photo Workshops—www.firstlighttours.com

PHOTOGRAPHY EQUIPMENT WEB SITES

BorrowLenses—www.borrowlenses.com

LensRentals—www.lensrentals.com

BOOKS

Davis, Neil. *Aurora Watcher's Handbook.* University of Alaska Press, 1992.

Akasofu, Syun-Ichi. *The Northern Lights: Secrets of the Aurora Borealis.* Alaska Northwest Books, 2009.

Checklist

CLOTHING
- Boots (the thicker the soles the better)
- Wool socks
- Thermal underwear
- Hand and foot warmers
- Glove liners
- Gloves or mittens
- Head covering
- Warm shirt/sweater
- Heavy coat (down works best)
- Warm pants (wool or insulated ski pants)

CAMERA ACCESSORIES
- Good tripod and easy-to-use tripod head
- Padding for tripod legs if using a metal tripod
- Cable release or remote
- Extra batteries (at least one)
- Lens cloth
- Memory cards (have plenty of storage)
- Small flashlight or head lamp
- Camera protection plan/gear

CAMERA EQUIPMENT
- Camera bodies (have a backup if possible)
- Lenses (wide-angle lens, preferably f/2.8 or f/1.4)
- Know where the most used controls are located

BEFORE LEAVING ON A TRIP
- Review the aurora forecast
- Check the weather forecast
- Know moon phase and rise times
- Determine when solar midnight is

CAMERA PREP
- Remove filters from lens
- Tape over LED light
- Lens hood attached (if you have one)
- Pre-focus lens and tape in place
- Test shot to ensure focus
- Set file type to RAW or RAW + JPEG
- Set white balance to daylight or auto
- Set 2-second timer if not using cable release
- Set ISO
- Turn auto review off
- Turn image stabilization off
- Set exposure mode to manual or aperture priority
- Set motor drive to continuous
- Decrease LCD brightness from default
- Set date/time stamp to local time (*optional*)
- If using aperture priority, set metering mode to evaluative and exposure compensation to +1

IN THE FIELD
- Scout and find good locations during the day
- Use multiple foregrounds
- Avoid breathing on the viewfinder
- Be patient—stay up until at least solar midnight to make sure you don't miss a good show (at least 2:00AM)
- Have warm drinks nearby

ENJOY THE SHOW
Take the time to watch this amazing event and enjoy its wonders.

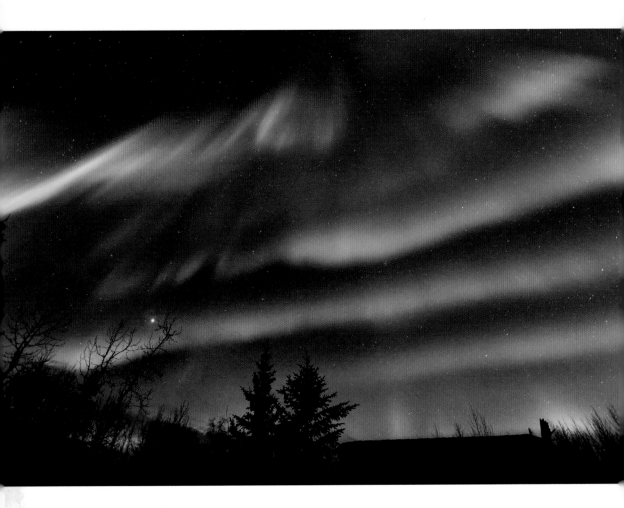

Take Time to Enjoy

Don't get too wrapped up with the details of taking a lot of shots and getting everything perfect. Take time to watch the amazing beauty going on overhead.

Luckily, with some camera setups, each shot is between 5 and 15 seconds—so you will have at least this much time to watch what is going on. It's all right to miss a few shots in favor of paying attention to the curtain as it ripples across the sky or as the aurora dances all over the place. Let your shots be the exclamation point to the "wow" being experienced.

There is nothing quite like seeing the sky come alive with a variety of colors, shapes, and movement of an active aurora. Unless you live in an area where the aurora appears regularly, there's a good chance you will never see something like this again. (But then again, I have had numerous people take an aurora photography workshop with me two, three, and even four times!)

Once you are familiar with the settings for northern lights photography and are comfortable working with your camera in the dark, you will be ready to capture the greatest light show on Earth. It's a great skill to learn and allows you to take images of much more than just what the eye can see as the sky erupts in front of you. To make the most of a trip to view and photograph the aurora borealis, many photographers choose to enroll in a guided workshop. Here are some questions to ask before choosing a northern lights workshop.

A WORKSHOP OR A TOUR?

Because of the increasing popularity of photographing the aurora, more trips are being offered than ever before. Some offer a tour to good locations but do not provide teaching. Tours are great if you don't need any hands-on help or just like going with a group of other photographers for the camaraderie.

HOW MANY TIMES HAVE THEY DONE THIS TRIP?

Find out how many times the leader has been to the area to ensure they know it quite well. They don't have to live there but they do need to know the location. Time is maximized by knowing the area and being in the right place at the right time.

DO THEY LISTEN?

This is an important aspect. Many people can talk about how to do something, but you also need to know they are there to answer all of the questions you have.

SOLID OR FLEXIBLE STRUCTURE?

Some trips have a set structure where you are at point A at this time and then go to point B at another set time. Others change things up based on weather, subject cooperation, and other factors. One is no better that the other—but try to match the tour/workshop to your preferences.

DO THEY ASK ABOUT YOUR HISTORY OR EXPECTATIONS?

This is an indication of how much you will learn. If subjects are covered based on your needs, there is a better chance the instruction will be helpful. Some cover this on the first day of a workshop.

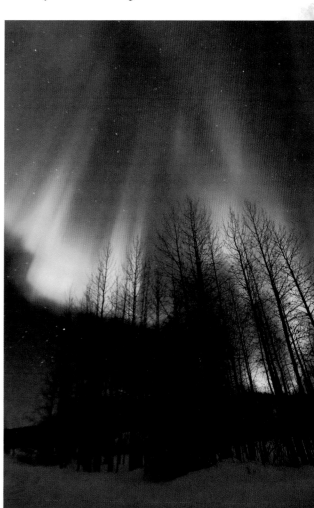

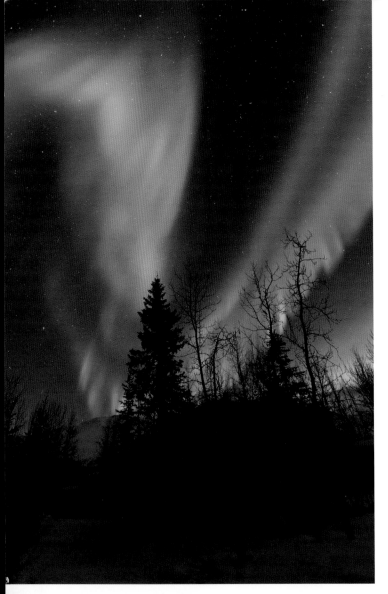

WHAT IS INCLUDED?

Never make assumptions. Always ask what you receive for your money. Water? Meals? Internet access? Transportation?

HOW LONG HAVE THEY BEEN LEADING WORKSHOPS?

More time spent leading groups is good. If they are good enough to have stayed in business for quite a few years, it shows that they love what they do.

IF THEY WRITE, LOOK FOR SAMPLES

Check previous writing by the instructor. It helps show that they know what they are teaching.

THE MIX OF FIELD AND CLASSROOM TIME

The goal is to shoot and get pictures, so you don't want to spend too much time in the classroom. There should be some instruction in this form, but not too much.

GET ON THE PHONE AND CHAT

While these questions can be answered by e-mail or looking at their web site, talking on the phone will let you get a feel for what the leader is like. You don't have to be best friends, but a good workshop leader will make you feel comfortable and be able to listen to your wants and desires for your time together.

HOW MUCH PHOTOGRAPHY EXPERIENCE?

Your leader should be an experienced shooter with a good knowledge of photography. It should not be just a hobby they've picked up recently to earn extra money.

HAVE THEY BEEN PUBLISHED?

If the workshop leader doesn't work at getting published in a lot of magazines and other places, there's a good chance they're leading workshops because it seems like an easy way to make money with their camera.

GET REFERENCES

Ask for recommendations from others who have done this trip. If they have nothing to hide, they will offer contact info for past attendees.

MAKE SURE YOUR NORTHERN LIGHTS WORKSHOP INCLUDES:

- Multiple locations for a variety of landscapes and foregrounds.
- At least six nights to allow for periods of low activity.
- A leader with good experience photographing the aurora.
- Enough shooting during the day to keep you busy.
- Bases within the auroral band, so you're not just hoping the display reaches south to where you stay.

LEARN MORE FROM THE AUTHOR OF THIS BOOK!

Here are some ways you can keep learning more about photography and places to share your images with others who have a passion for this kind of photography.

First Light Online Newsletter—Sign up to receive our photography newsletter with photo tips, sponsor specials, workshop recaps, and more by sending an e-mail with "Newsletter" in the subject line to the address below.

Workshops—Whether your passion is northern lights, wildlife, nature, macro, or landscape photography, First Light offers instructional photo expeditions to many top spots around the world including the most popular, Alaska Northern Lights.

Online Classes (www.firstlighttours.com/online classes.html)—Take your photography to the next level with an online photography class. Watch your skills and techniques improve as you progress through each course with one-on-one access for any questions you have. You'll gain knowledge and master new techniques—as well as learn how to get the most out of your equipment. Choose from any of the six-part, self-paced classes, which have no set start or end dates. All classes include critiques for each lesson.

Facebook (www.facebook.com/firstlight workshops)—Follow Andy and First Light on Facebook for tips and tricks, notes about upcoming workshops, and photos from recent outings. Post your image of the northern lights to let others see what you learned.

E-mail a Friend—If this book has helped you learn how to photograph the northern lights, I'd love if you could tell a friend about it by directing them to my web site to take advantage of other learning opportunities.

My Gift to You—After having purchased and read this book, if you would like to join me on an incredible journey to see and photograph the northern lights, contact me and receive $100 off the price of registration for the next northern lights workshop being offered.

Contact Andy:
Workshop Web: www.firstlighttours.com
Email: firstlightphotoworkshops@gmail.com
Facebook: facebook.com/firstlightworkshops

Index

Shoot Cold

Whether you live in the city or country, Joe Classen shows you how to shake the cabin fever and make winter your most creative and exciting photography season. *$37.95 list, 7x10, 128p, 250 color images, index, order no. 2101.*

Bushwhacking: Your Way to Great Landscape Photography

Spencer Morrissey presents his favorite images and the back-country techniques used to get them. *$37.95 list, 7x10, 128p, 180 color images, index, order no. 2111.*

Conservation Photography Handbook

Acclaimed photographer and environmental activist Boyd Norton shows how photos can save the world. *$37.95 list, 8.5x11, 128p, 230 color images, index, order no. 2080.*

How to Photograph Bears

Joseph Classen reveals the secrets to safely and ethically photographing these amazing creatures in the wild—documenting the beauty of the beast. *$37.95 list, 7x10, 128p, 110 color images, index, order no. 2112.*

Mastering Composition

Mark Chen explores a key step in the creation of every image: composition. Dive deep into this topic and gain total control over your images. *$37.95 list, 7x10, 128p, 128 color images, index, order no. 2081.*

Digital Black & White Landscape Photography

Trek along with Gary Wagner through remote forests and urban jungles to design and print powerful images. *$34.95 list, 7.5x10, 128p, 180 color images, order no. 2062.*

Wildlife Photography

Joe Classen teaches you advanced techniques for tracking elusive images and capturing magical moments in the wild. *$34.95 list, 7.5x10, 128p, 200 color images, order no. 2066.*

Magic Light and the Dynamic Landscape

Jeanine Leech helps you produce more engaging and beautiful images of the natural world. *$27.95 list, 7.5x10, 128p, 300 color images, order no. 2022.*

The Complete Guide to Bird Photography

Jeffrey Rich shows you how to choose gear, get close, and capture the perfect moment. A must for bird lovers! *$29.95 list, 7x10, 128p, 294 color images, index, order no. 2090.*

Professional HDR Photography

Mark Chen helps you maximize detail and color with high dynamic range shooting and postproduction. *$27.95 list, 7.5x10, 128p, 250 color images, order no. 1994.*